TWO GUYS
FOUR CORNERS

DON IMUS & FRED IMUS

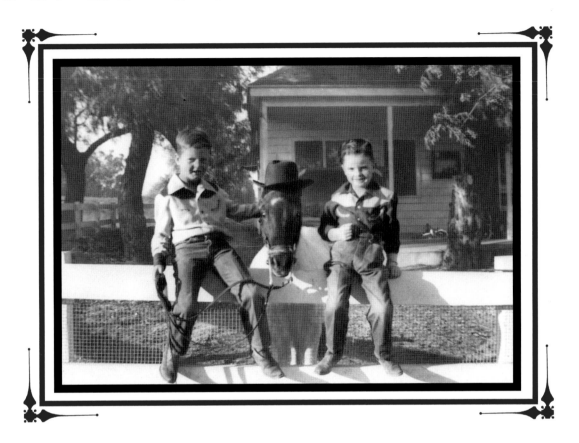

TWO GUYS
FOUR CORNERS

GREAT PHOTOGRAPHS, GREAT TIMES, AND A MILLION LAUGHS

Villard New York

Grateful acknowledgement is made to The Putnam & Grosset Group for permission to reprint marginal
illustrations from *The Book of Cowboys* by Holling C. Holling. Copyright © 1936, 1962 by The Platt & Munk Co., Inc.
Reprinted by permission of The Putnam & Grosset Group

Library of Congress Cataloging-in-Publication Data is available.

ISBN: 0-679-45307-5

Random House website address: http://www.randomhouse.com/

Printed in the United States of America on acid-free paper

24689753

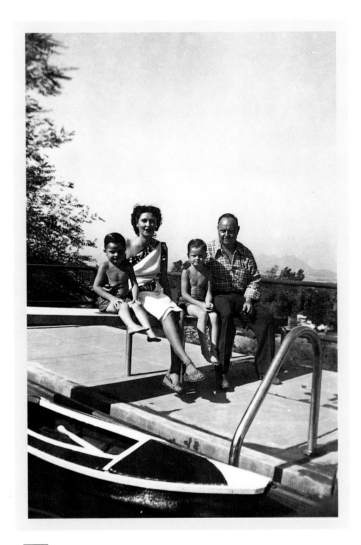

FOR OUR PARENTS

John D. Imus
1904–1962

Frances E. Moore
1910–1982

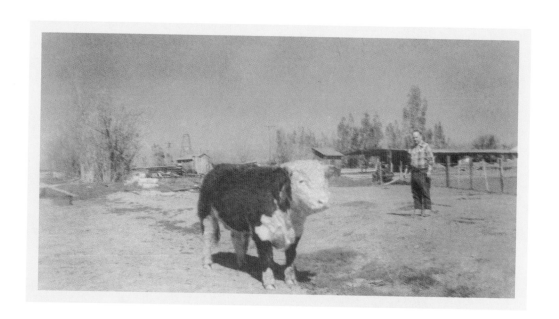

INTRODUCTION

Fred and I grew up on a cattle ranch in northern Arizona, a thirty-five-thousand-acre spread halfway between Kingman and Seligman—a place called the Willows. From the old Route 66, it was fifty miles of dirt road to the main ranch house.

Our love of the Southwest grew out of attending Easter sunrise services at the Grand Canyon with our parents. On trips to the old trading post at Cameron, through Tuba City, on to the Hopi reservation and Second Mesa. To Page and Lake Powell; to Rainbow Bridge. From Flagstaff to the once thriving Winslow—through the Petrified Forest to the ruins at Chaco Canyon. From New Mexico's white sands to the red rocks of Sedona.

Hanging out with our father in the notorious saloons of the Old West romanticized and enhanced our affection. The Palace in Prescott. The *Crystal* Palace in Tomb-

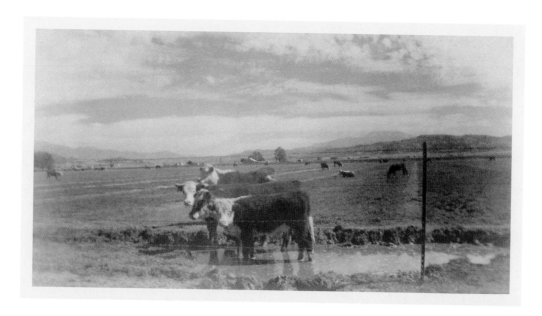

stone. The great, ornate bar at El Tovar on the south rim of the Grand Canyon. Watering-holes-in-the-wall in Williams and Ash Fork. Drinking beer with the Indians at Peach Springs.

And remarkable adventures: Watching the old man and Uncle Elmer Imus (then the police chief of Kingman) shoot it out on the ranch with neighbors over rustled cattle. Roping mountain lions with the ranch hands. Fording swollen creeks in an open truck full of supplies—we always saved the whiskey. Breaking broncos, branding cattle, and making jerky. Fred on the backs of Brahma bulls in rodeos.

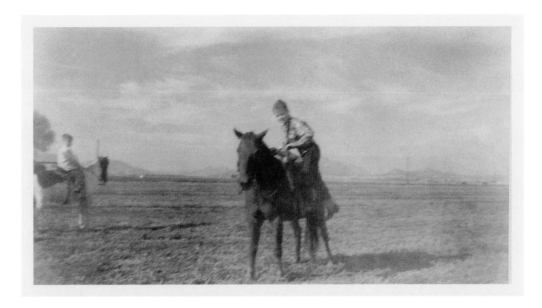

My brother and I began to photograph the Southwest in the early 1970s. From the Grand Canyon down through the Painted Desert to the Navajo Nation headquarters at Window Rock. To Canyon de Chelly, Monument Valley, Bryce Canyon, Canyonlands, and Mesa Verde. To the old pueblo at Taos; to Sante Fe and Durango. And a thousand photographs along the roads that were *always* the best shots.

Great photographs, great times, and a million laughs on a journey that always leads back to the Willows.

—Don Imus, New York

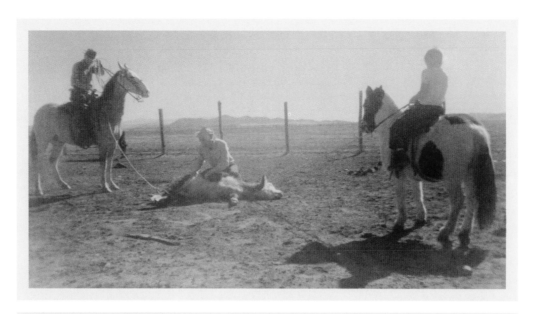

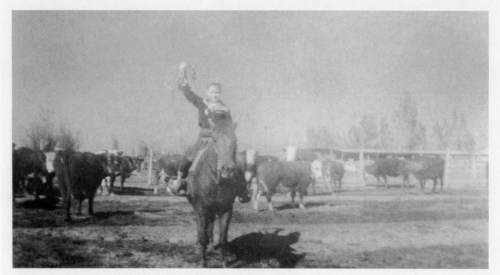

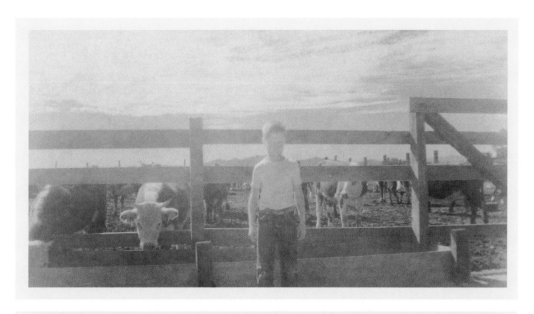

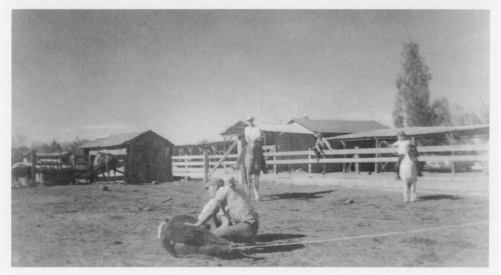

TWO GUYS
FOUR CORNERS

MONUMENT VALLEY
VISITOR CENTER, UTAH.

Hello? See the fog?

It's not going to go away.

You can't see anything.

This is a really stupid photograph.

Hello?

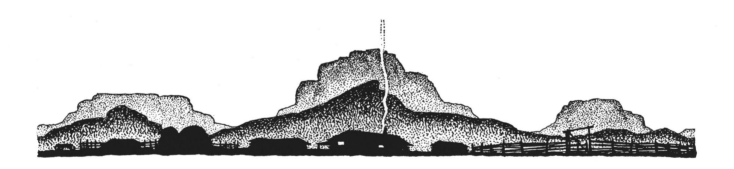

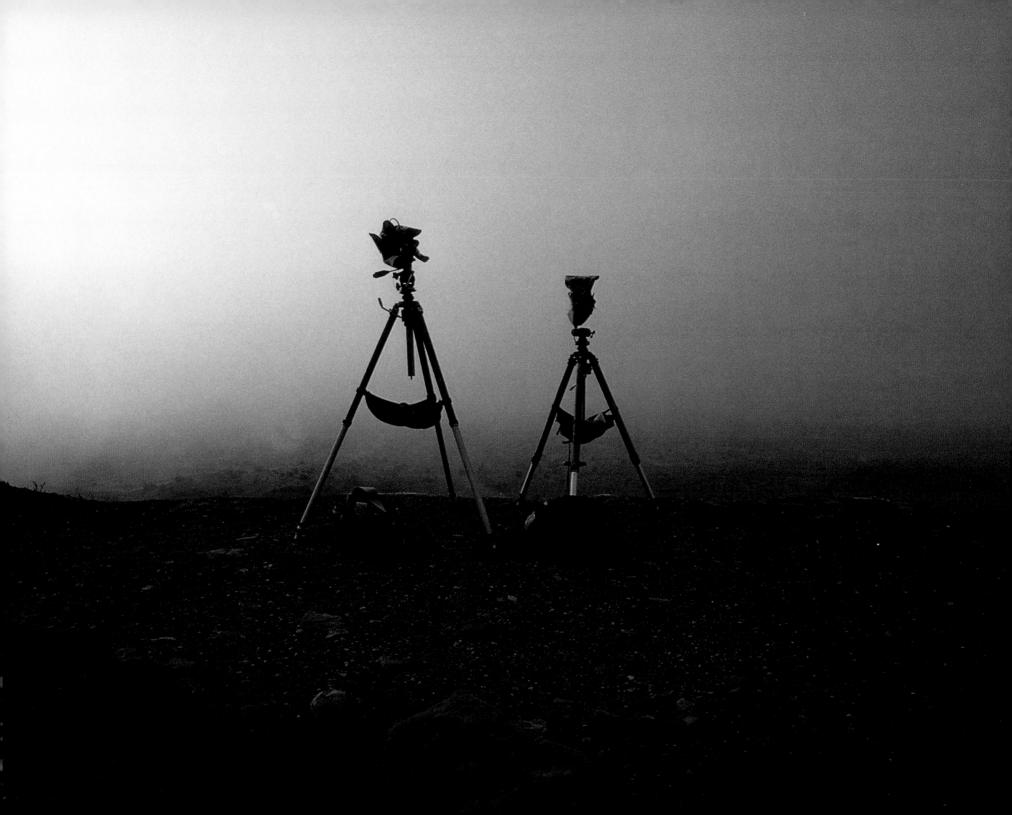

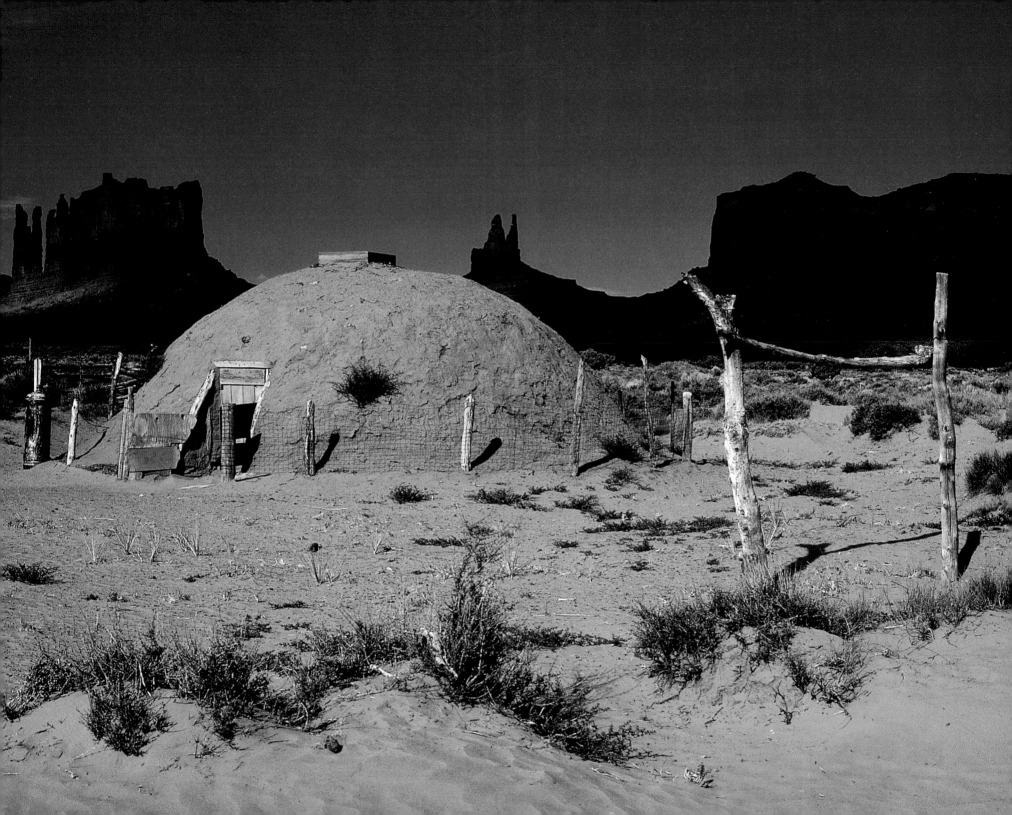

A HOGAN ON THE UTAH SIDE APPROACHING MONUMENT VALLEY.

There is a painting of this scene that hangs in many of the rooms at Gouldings Lodge in Monument Valley, Utah. We wanted to find it and *photograph* it.

No one seemed to know where it was . . . or if it even existed. It is important to remember that most Native Americans hate white people. Particularly fat white tourists who buy their equally fat, obnoxious kids cheesy tom-toms and cheap war bonnets and demand that the Indians pose for pictures with the little bastards wearing this shit. And so, asking local Navajos for information is often met with grunts of indifference and feigned ignorance. Suffering those sorts of indignities and the fact that we fucked them out of all the decent land in a country that was initially theirs seems to me to justify their feelings.

A couple of bottles of Jack Daniel's and twenty bucks later . . . just kidding. We obviously found it—ourselves. Notice the propane gas tank to the left of the hogan. So much for roughing it on the reservation.

THE TOTEM POLE,
MONUMENT VALLEY, UTAH.

Fred has the definitive shot of this scene. This is evidence that a shitty shot can also be taken of the identical site under dramatically different light and cloud conditions and still end up in a hideously overpriced book of photography.

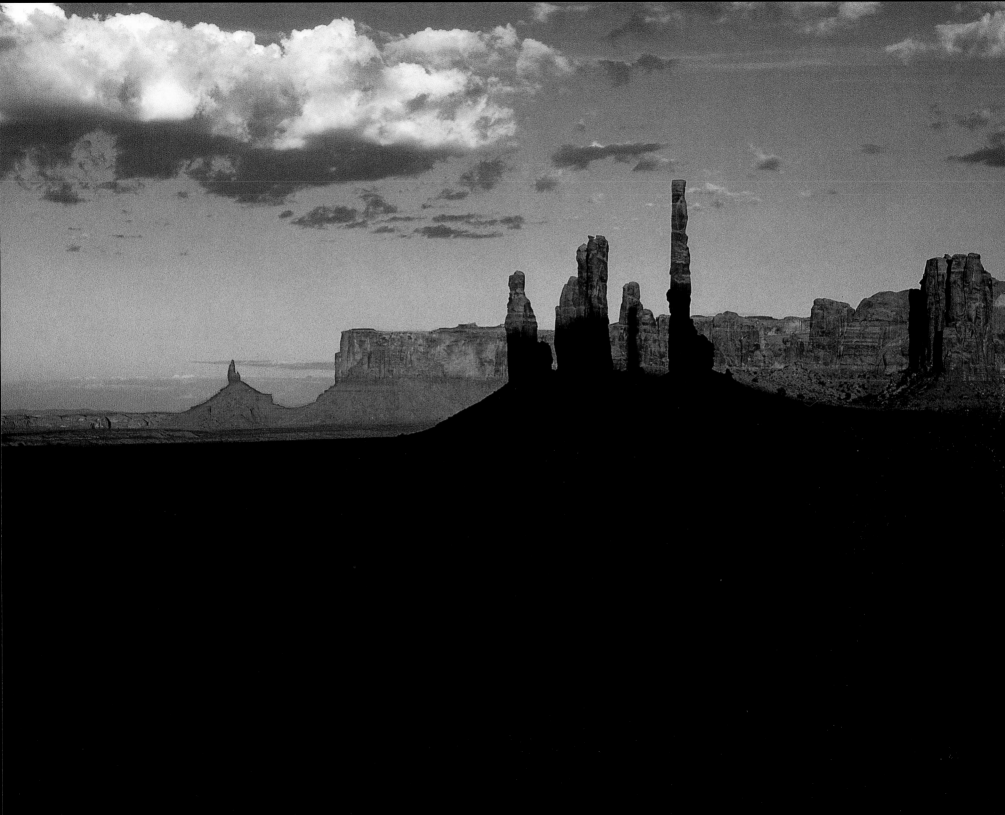

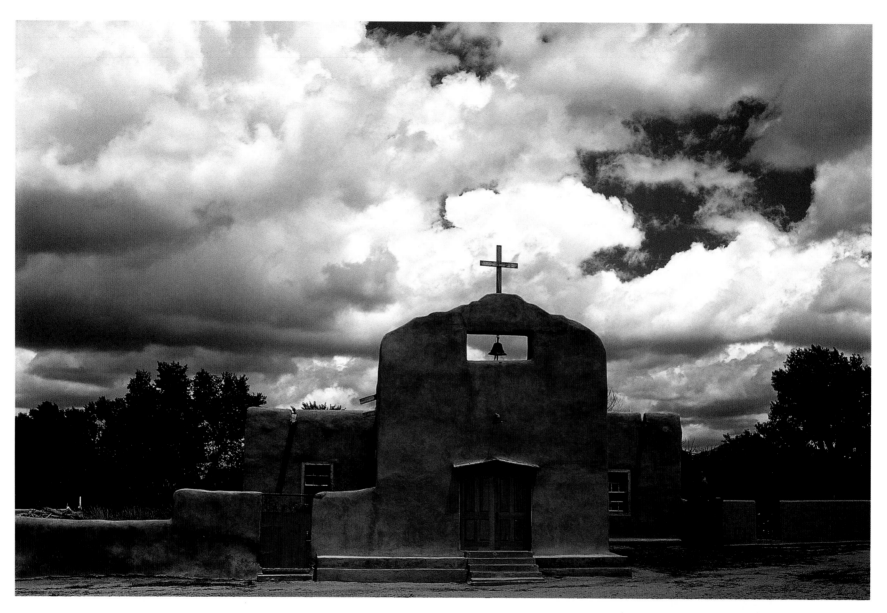

TAOS, NEW MEXICO.

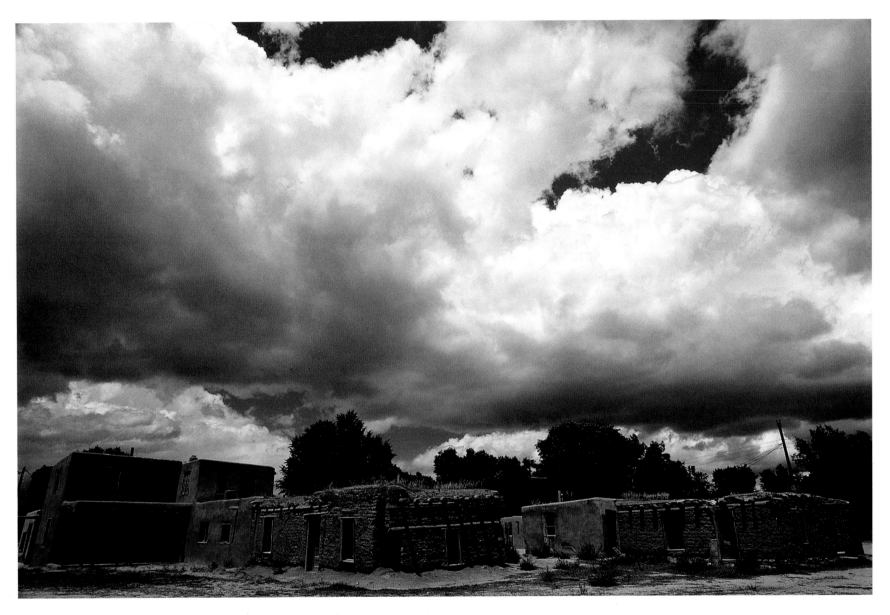

TAOS PUEBLO, TAOS, NEW MEXICO.

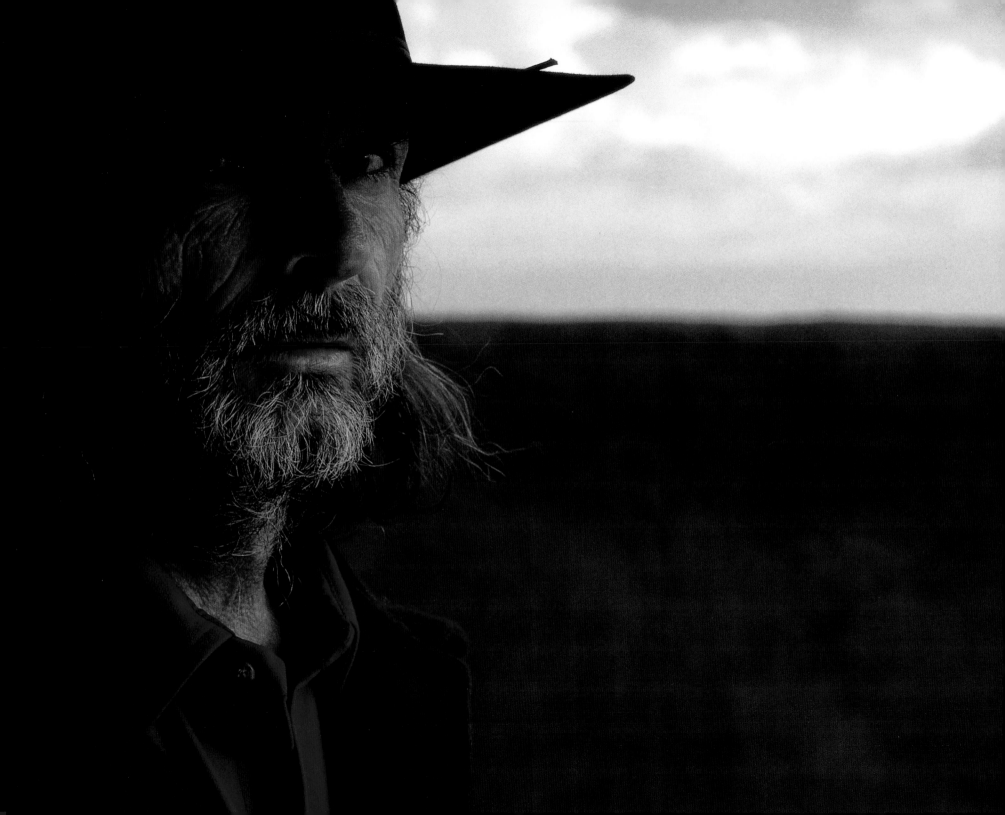

FRED IMUS,
SANTA FE, NEW MEXICO.

Diane Arbus lives.

Totem Pole,
Monument Valley, Utah.

In the summer of 1988 Fred and I hired a Navajo Indian guide and drove our truck to a location in Monument Valley that overlooks a rock formation the Indians call the Totem Pole. We carried our cameras and tripods up a sand dune, set up, and realized we'd left the cigarettes in the truck. As I hiked back down to get them, storm clouds gathered in what had been an otherwise fairly ordinary blue sky. While I was gone, Fred shot this photograph with a Nikon F3 using Kodachrome 25 slide film. He thinks he overexposed it a stop or two. Probably using a 50mm lens at f/22 for two or three seconds. Clearly a lucky shot. By the time I got back with the Marlboros, the sky had cleared. The point here is, any moron who doesn't smoke could have taken this photograph. Even you. Or Al Gore.

RAZORBACK HOG

TEXAS LONGHORN

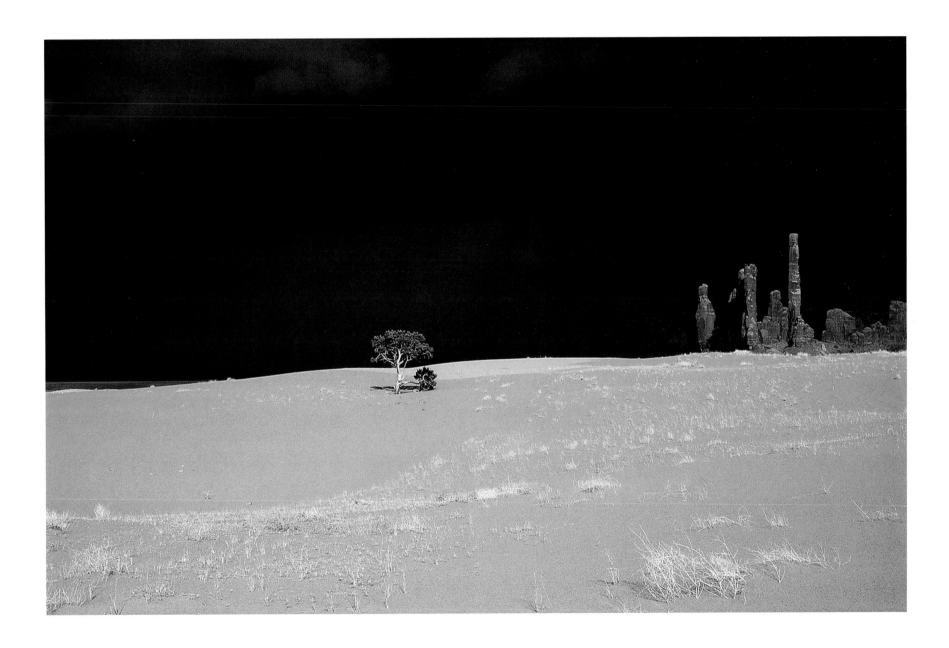

ENGLISH RIDING SADDLE

THE FIRST SADDLE WAS A THICK PAD

WAR SADDLE

HITCHING POST, MONUMENT VALLEY, UTAH.

A great shot.

Want to know how it was taken?

F-stop? Speed? Overexposed? Underexposed?

Call Fred: 1-800-272-1957.

SPANISH

EARLY MEXICAN

LATE MEXICAN

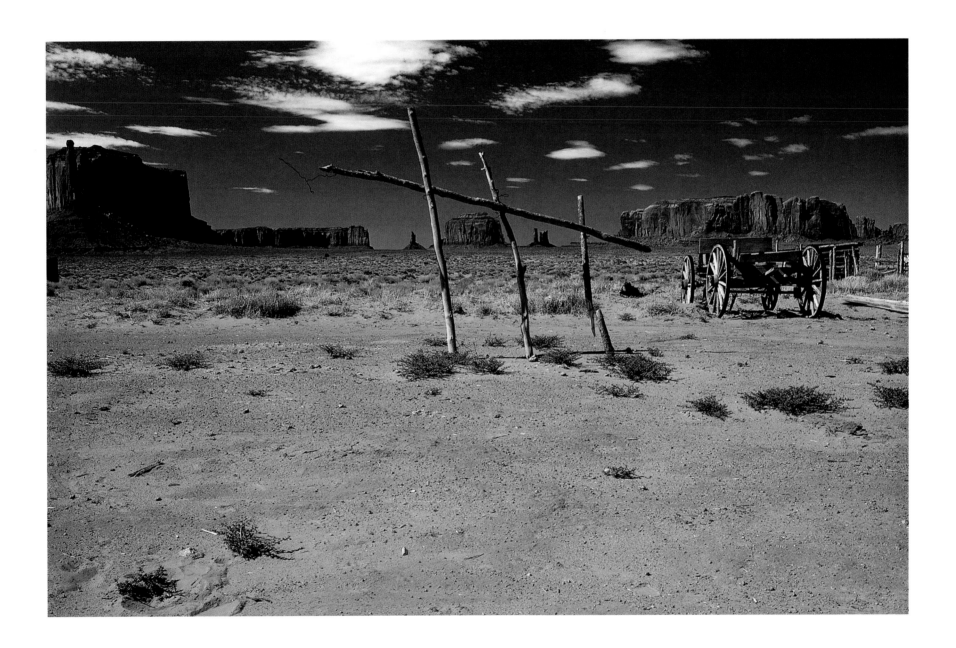

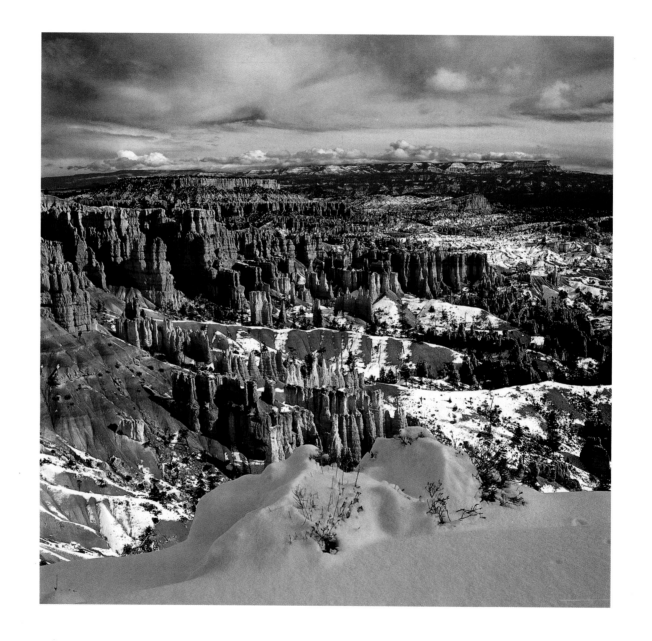

BRYCE CANYON, UTAH.

I have a policy regarding winter photographs. If it's below thirty degrees and the shot is not within fifty yards of the truck, let some nitwit willing to dress up like a fucking Eskimo take it.

As luck would have it, the location for this shot was the initial scenic turnoff in Bryce Canyon National Park. It *was* cold, so I didn't have to shoot around a horde of fat tourists driving recreational vehicles bigger than Willie Nelson's bus.

MONUMENT VALLEY, UTAH.

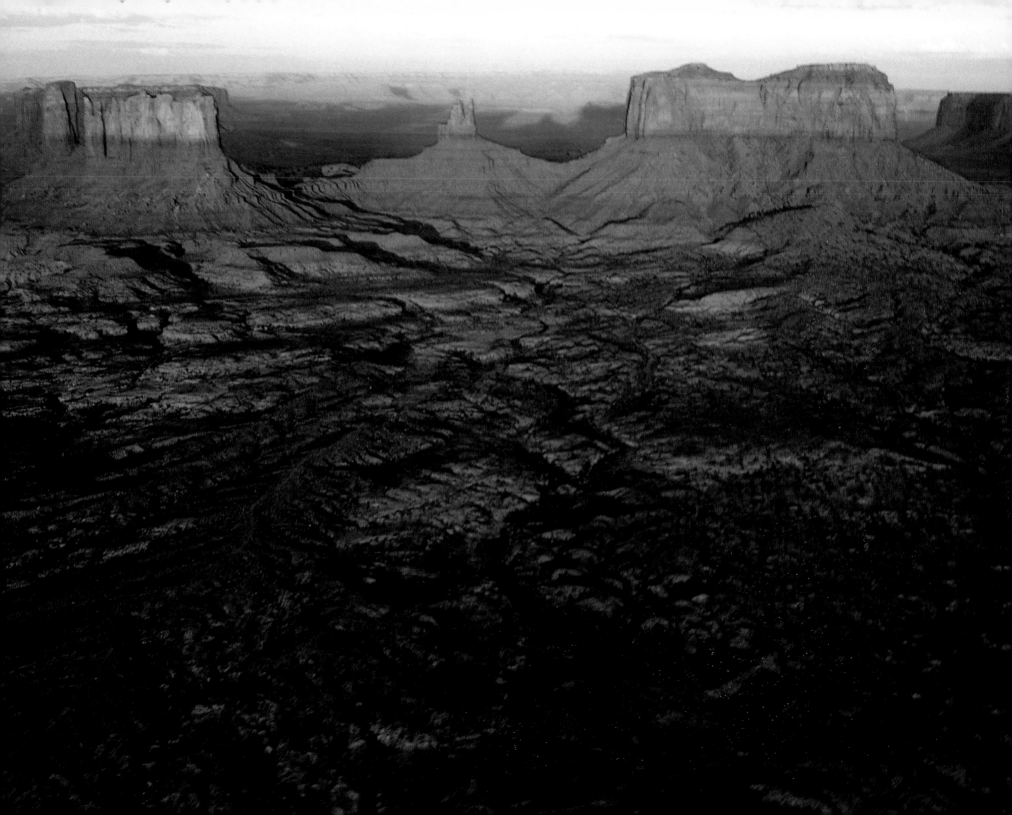

Monument Valley, Utah.

Look carefully in the mid-foreground. The figure posing there is not a Navajo deep in contemplation of his homeland. It is my then twelve-year-old nephew Don Imus (Fred's son).

He's now twenty, working for his father in Santa Fe, and still bitching about having to sit where you see him.

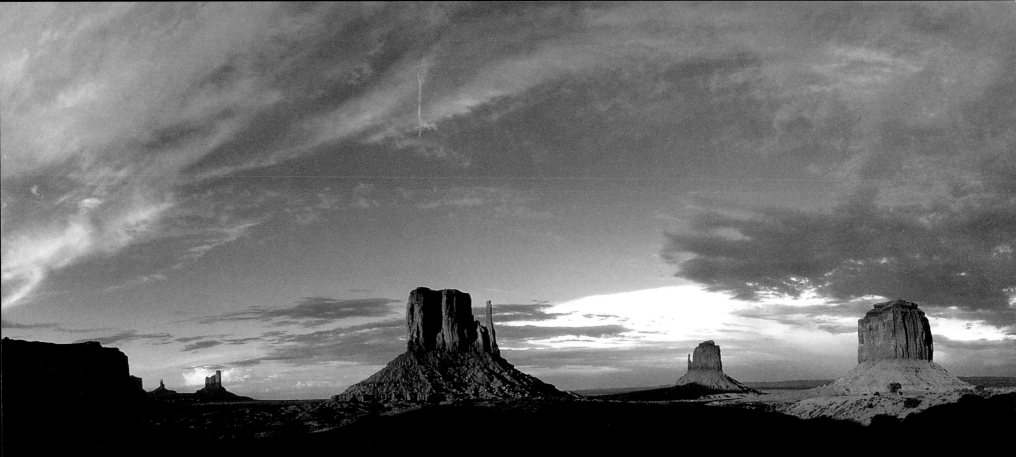

DURANGO–SILVERTON TRAIN.

A train full of fat tourists.

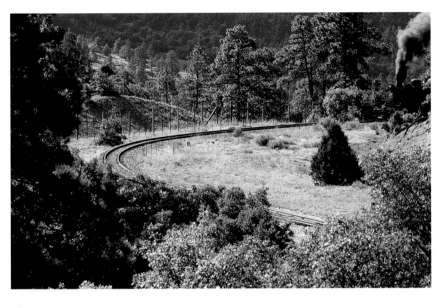
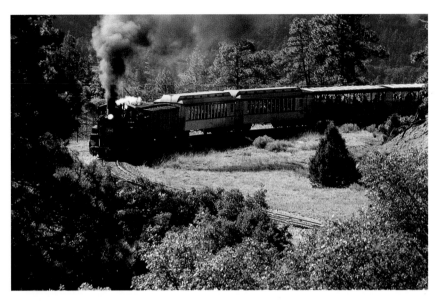
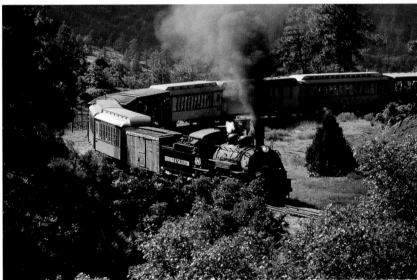
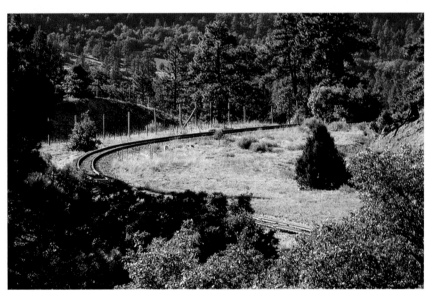

COMB RIDGE, UTAH.

The tree is out of focus.

Hey! The tree's out of focus!

It's art.

Oh, I get it.

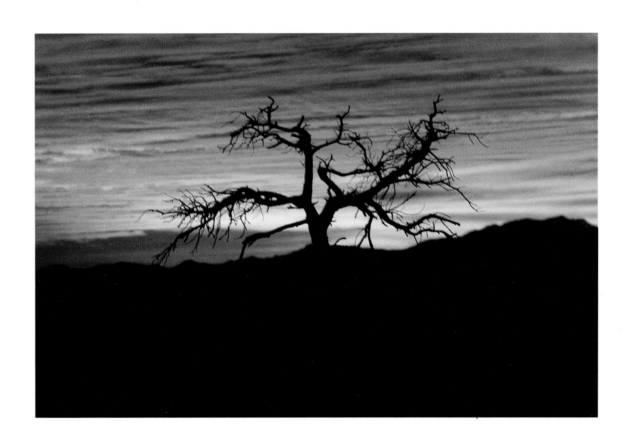

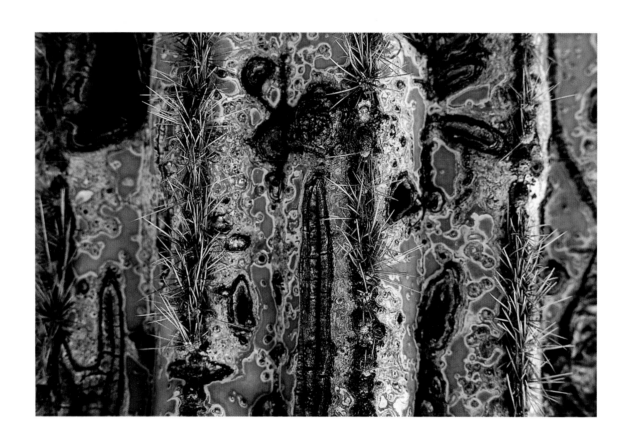

CACTUS, ARIZONA.

Well, actually, it's either a cactus
or Helen Gurley Brown's neck.

THE GRAND CANYON, ARIZONA.

The wind was about to blow my hat off. I was inches from falling thousands of feet to my death. Thank God I lived to include this fabulous shot in this very fine book.

MEXICAN STYLE SPUR

AMERICAN SPUR

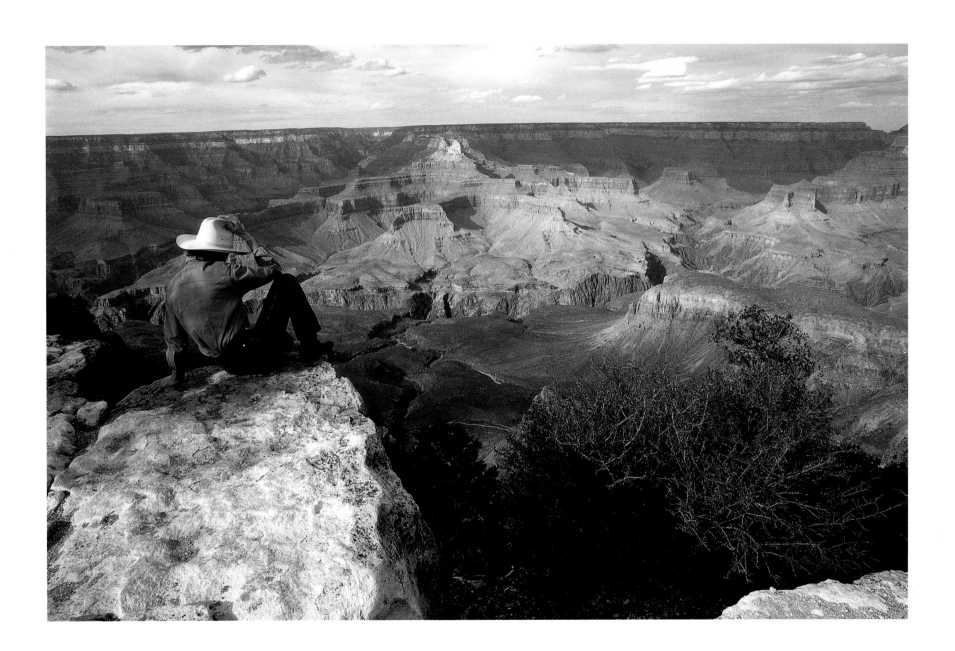

THE FLAMING ARCH, A SLOT CANYON OUTSIDE PAGE, ARIZONA.

This particular slot canyon is located about sixty miles southeast of Page, Arizona. Reaching the site required a couple hours of hiking, then lowering ourselves into the canyon with ropes and makeshift ladders and crawling through areas not much wider than eighteen inches. The middle of July. A hundred and five degrees. An absolute fucking nightmare.

The shot took hours to set up. More hours waiting for the sun to shine into the canyon, and then a nineteen-second exposure.

I've yet to show this photograph to *anyone,* explain how it was taken, and have them give a shit.

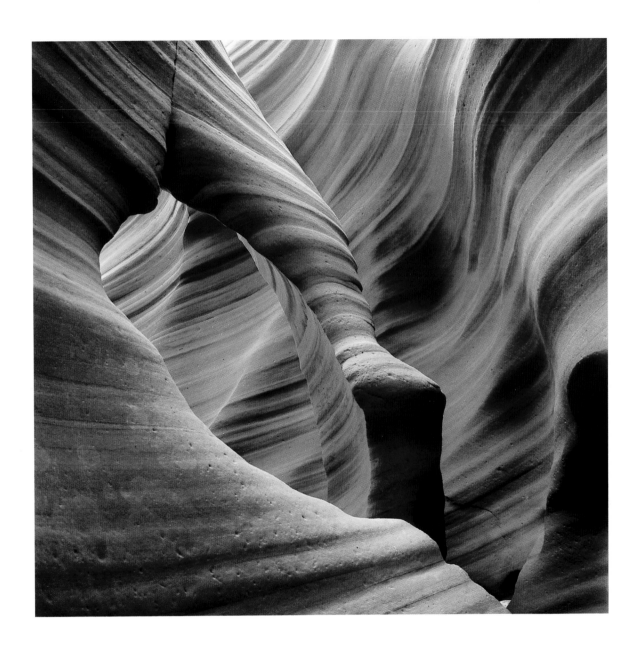

ANTELOPE CANYON, PAGE, ARIZONA.

If hiking to the Flaming Arch was the Bataan Death March, this was at least Marine Corps boot camp. However—and unfortunately—Antelope Canyon *is* reasonably accessible, which essentially means I was annoyed and inconvenienced by mostly German tourists in hiking boots tripping over my tripods—annoying Nazi bastards with disposable Kodaks shooting hand-held photographs that would look like they were taken at night in a coal mine.

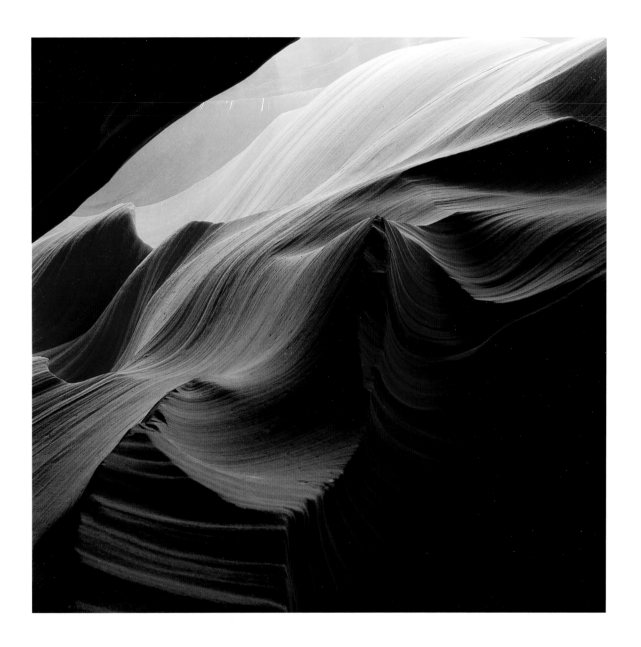

SLOT CANYON, PAGE, ARIZONA.

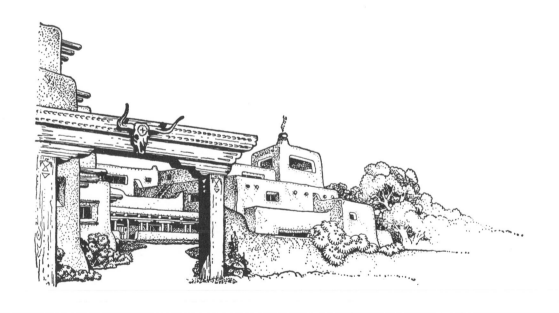

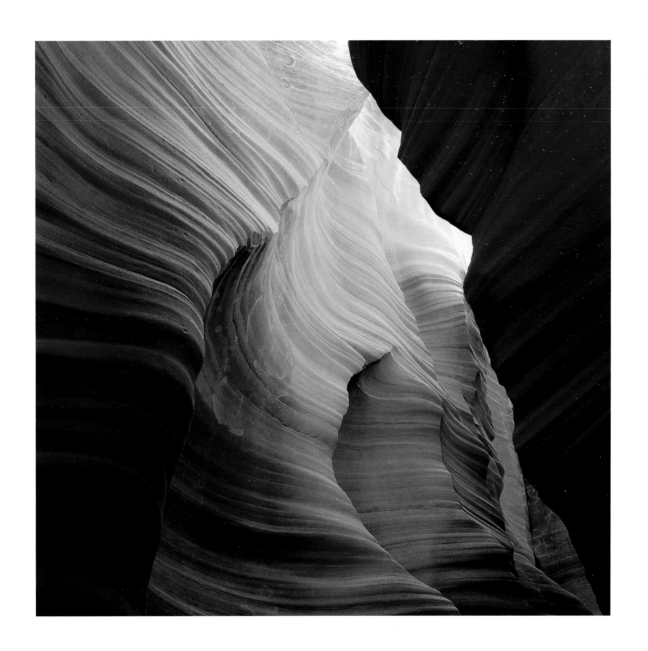

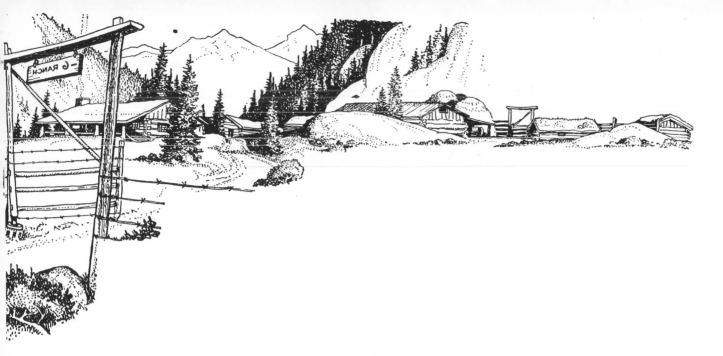

SLOT CANYON, PAGE, ARIZONA.

We found Madonna's baby in here.

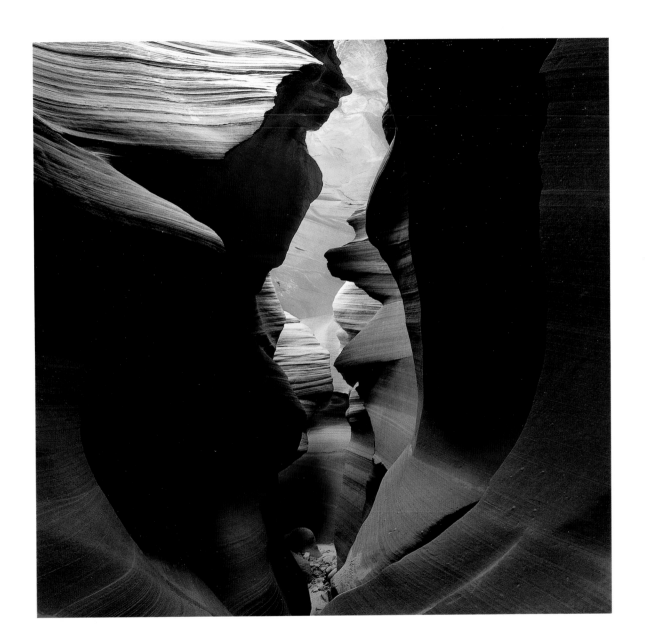

ABIQUIU, NEW MEXICO.

Located halfway between the Ghost Ranch and Georgia O'Keeffe's home.

The Ghost Ranch is now owned by a remarkably unfriendly religious cult that will provide you with no information regarding the nearby residence once occupied by Ms. O'Keeffe.

Her home can be viewed by appointment only . . . requiring a six-month wait. The people in Abiquiu are no more forthcoming than the assholes at the ranch.

Weird.

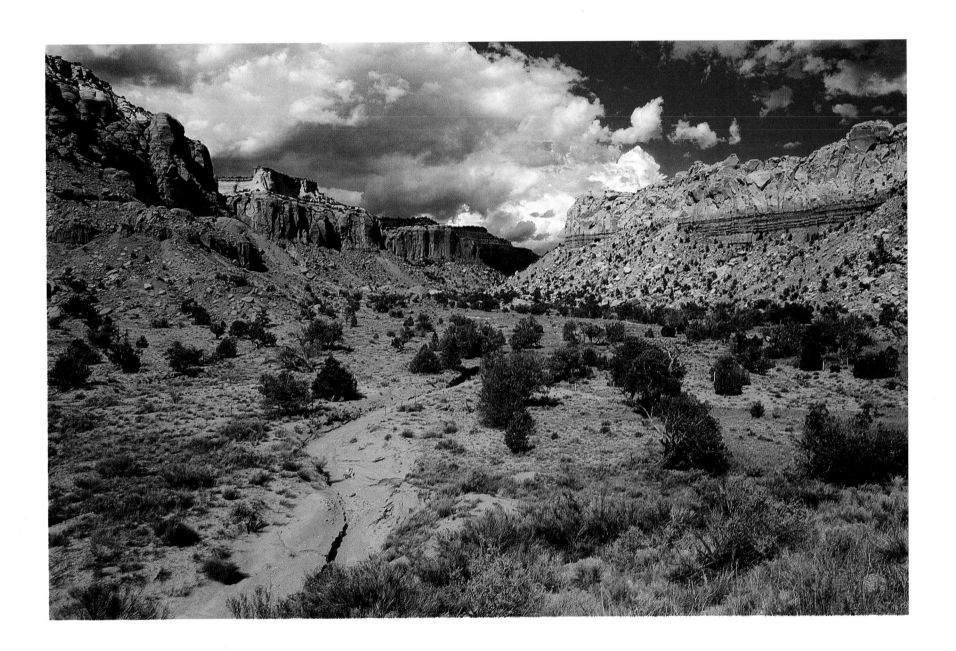

CLIFF PALACE,
MESA VERDE, COLORADO.

The most remarkable aspect of this largest and best-preserved ruin in the Southwest is that some gangster real estate goon has not convinced the Indians to turn it into a fucking casino.

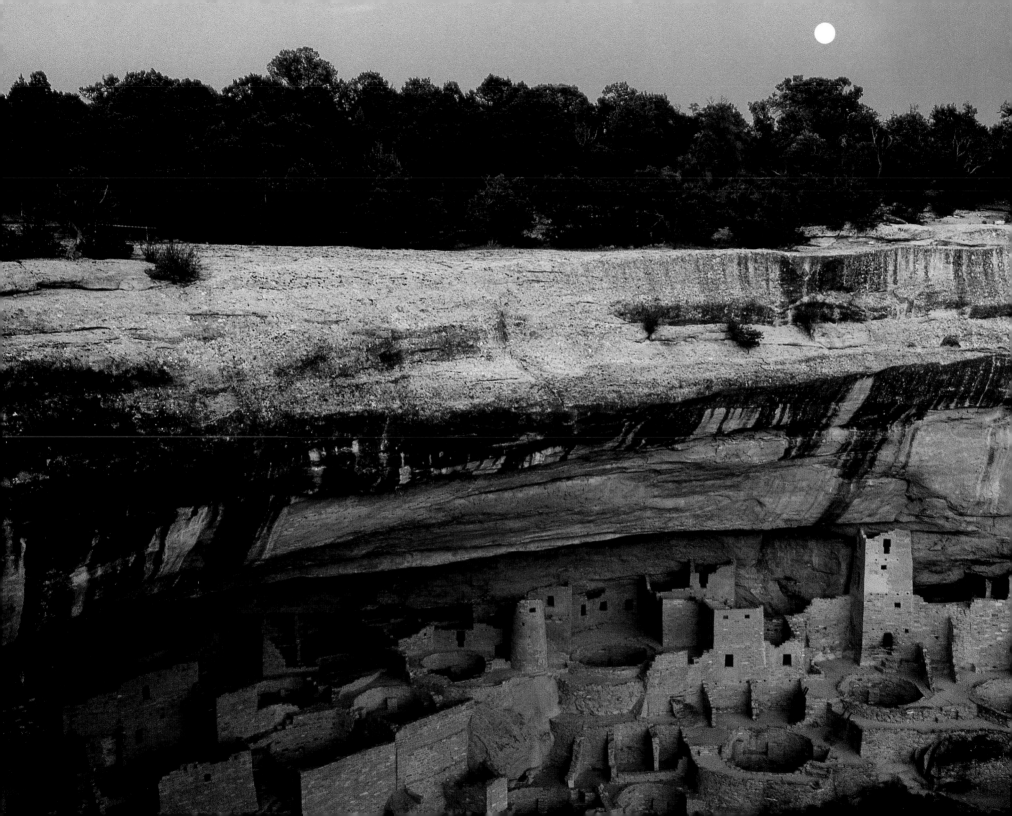

BLUE MESA,
THE PAINTED DESERT, ARIZONA.

Fred insisted that I was wasting my time photographing what is a) not a mesa, and b) not blue.

This very fine shot proves Fred is a sour old fool with an unfortunate attitude and limited vision.

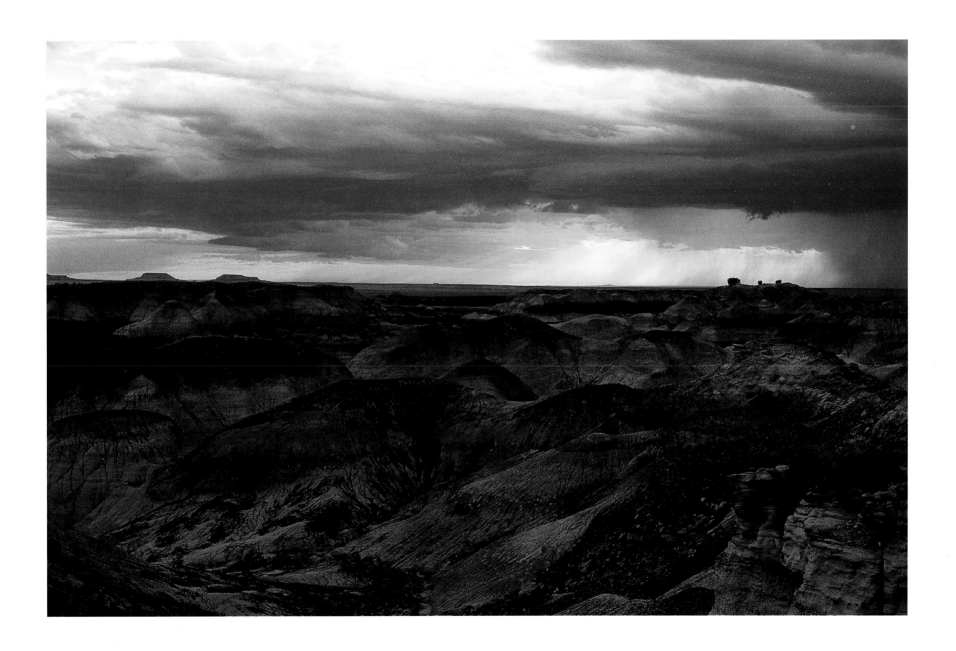

THE PAINTED DESERT, ARIZONA.

Here's a photo tip for those of you who are not professional photographers possessed of the artistic genius to capture the subtle beauty of the Southwestern desert: Check to be sure there is film in your camera.

In other words—any moron could have taken this. And in fact, a moron *did* take it.

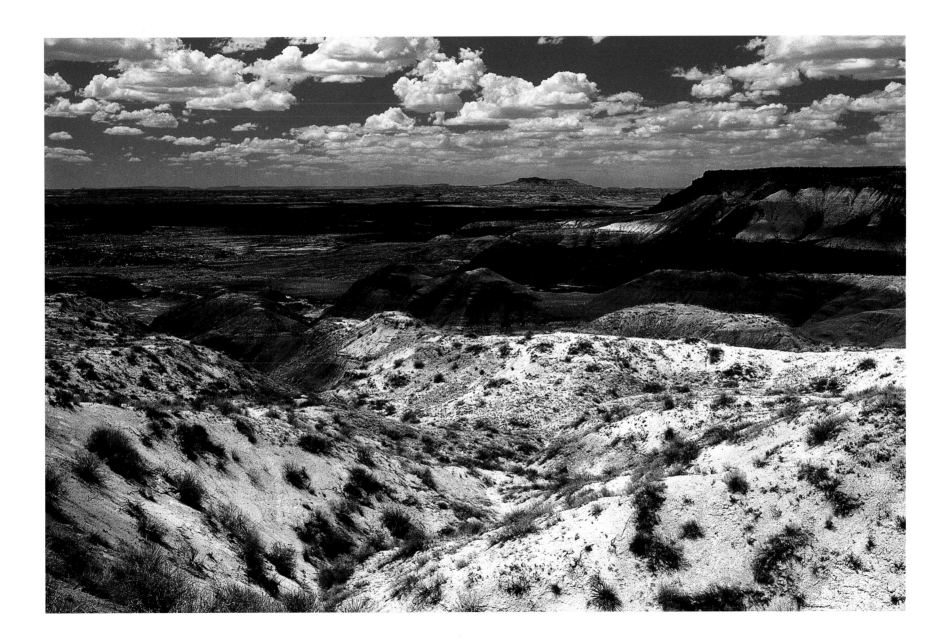

Cactus flowers,
Santa Fe, New Mexico.

When you are reduced to taking pictures of flowers, you've pretty much run out of ideas for majestic sweeping, photographic masterpieces of the great Southwest.

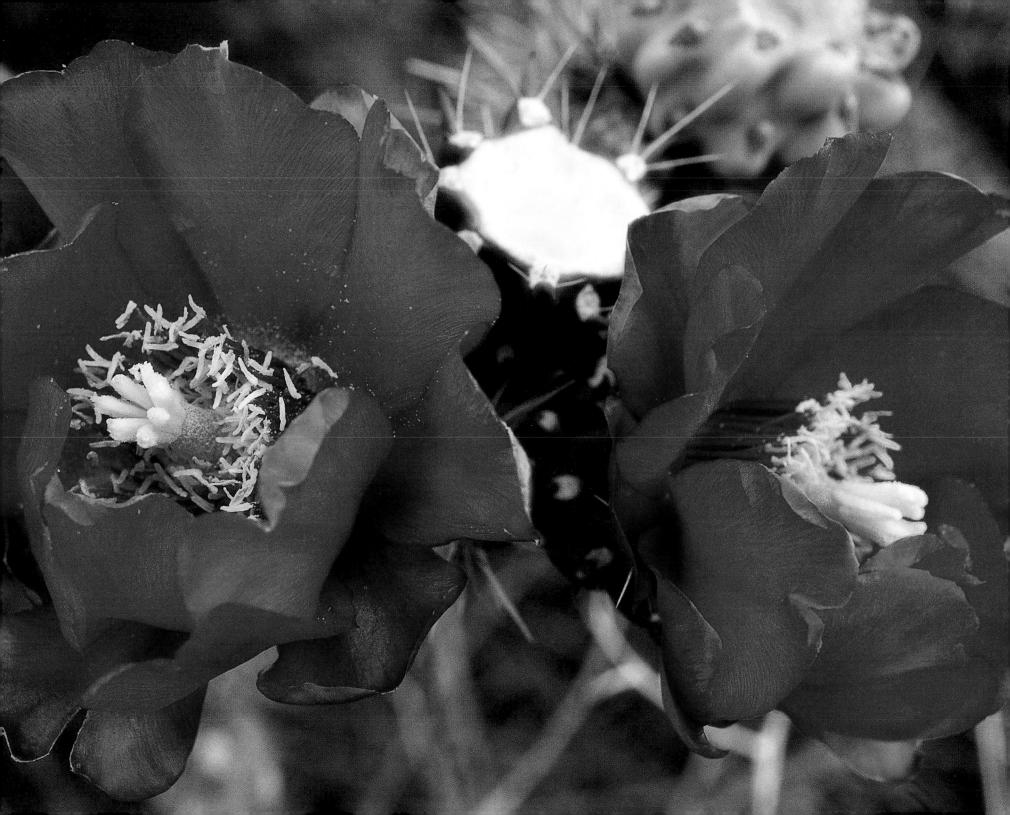

ALONG THE ROAD IN NORTHERN NEW MEXICO.

Taken in the summer of 1987.

The mountain is still there.

The horses have probably moved,

or more likely they're dead.

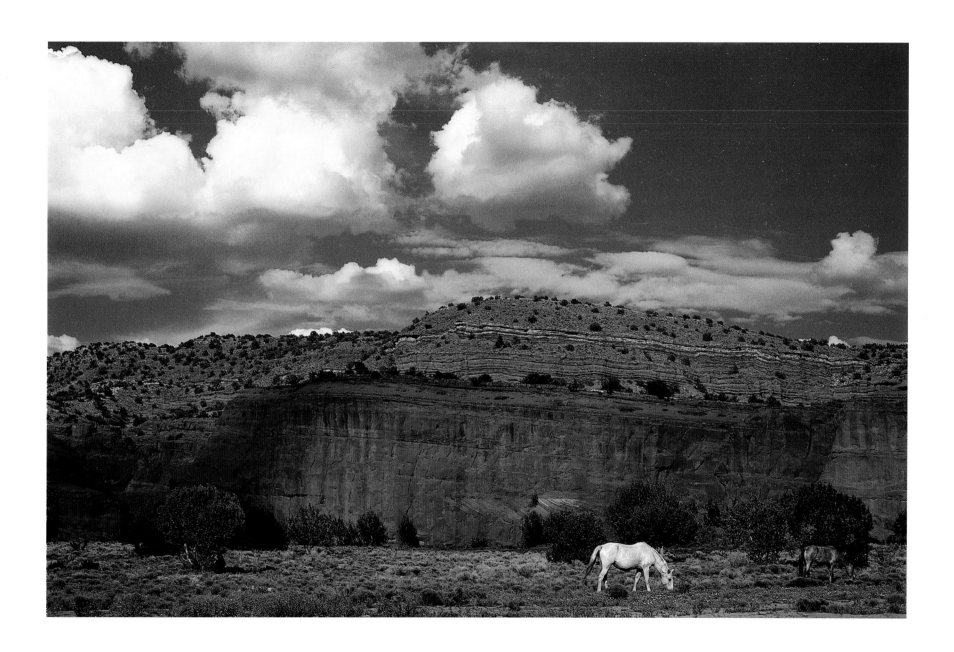

A WINDMILL ALONG A NORTHERN NEW MEXICO HIGHWAY.

In every book of photography of the Southwest there is the obligatory windmill shot. You usually don't even have to get out of your truck to take it.

While I don't have a record of the circumstances for this particular photograph, it appears to be winter and it was probably freezing. If I had to guess, I'll bet we didn't even slow down.

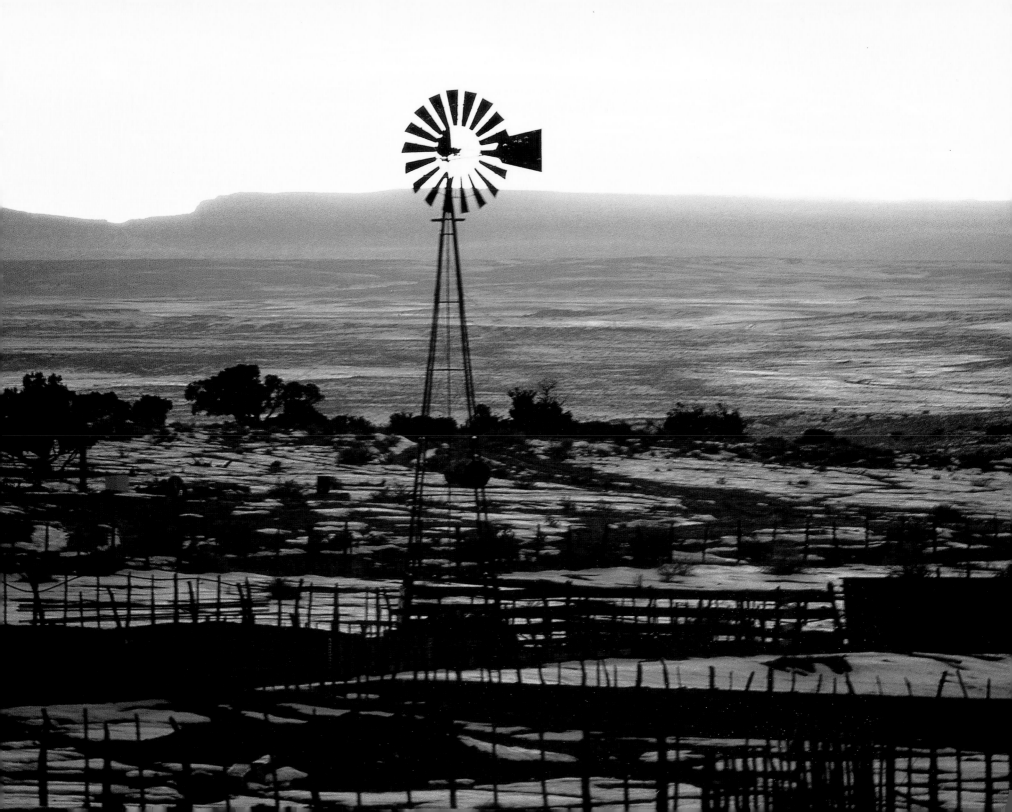

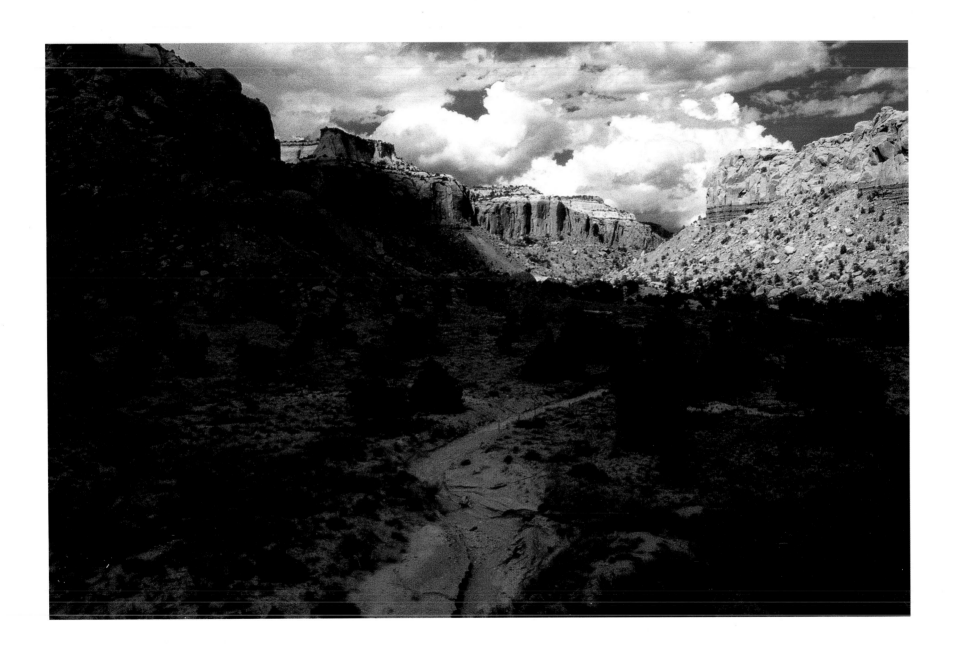

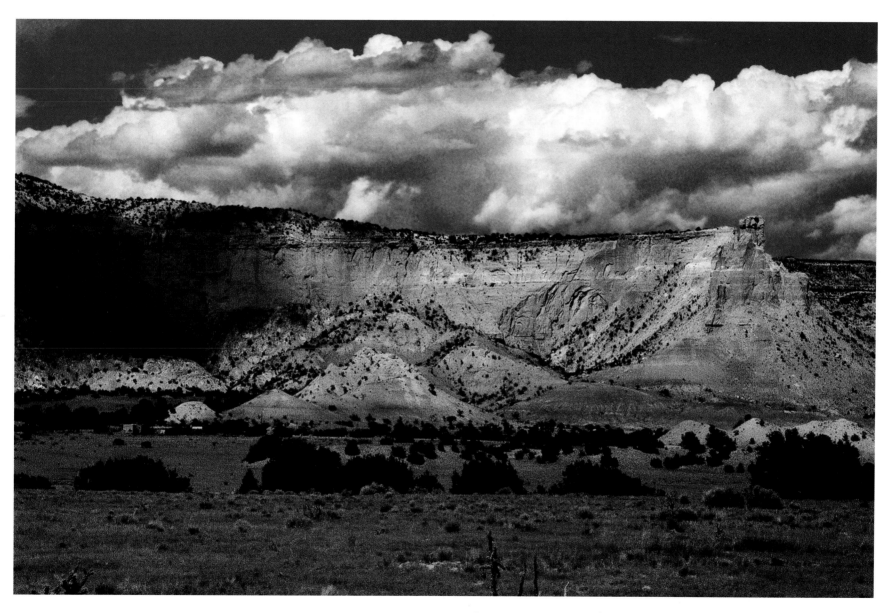

ABIQUIU, NEW MEXICO.

AT THE CHACO CANYON ANASAZI RUINS, NEW MEXICO.

The Anasazi ("ancient ones" in the Navajo language) built about a dozen pueblos that at one time housed nearly seven thousand people. The network of roads, system of irrigation ditches, elaborate buildings, basketry, and pottery reveal what was once a sophisticated society.

However, thanks to thousands of thieving tourists climbing all over what are now ruins—knocking shit over and stealing artifacts—what we have here is pretty much a bomb site.

It all looks remarkably like any inner city in America. Not much that I was interested in photographing. I did, however, manage to persuade this old squaw, who was tending sheep nearby, to pose for this photograph in front of a crumbling pueblo wall.

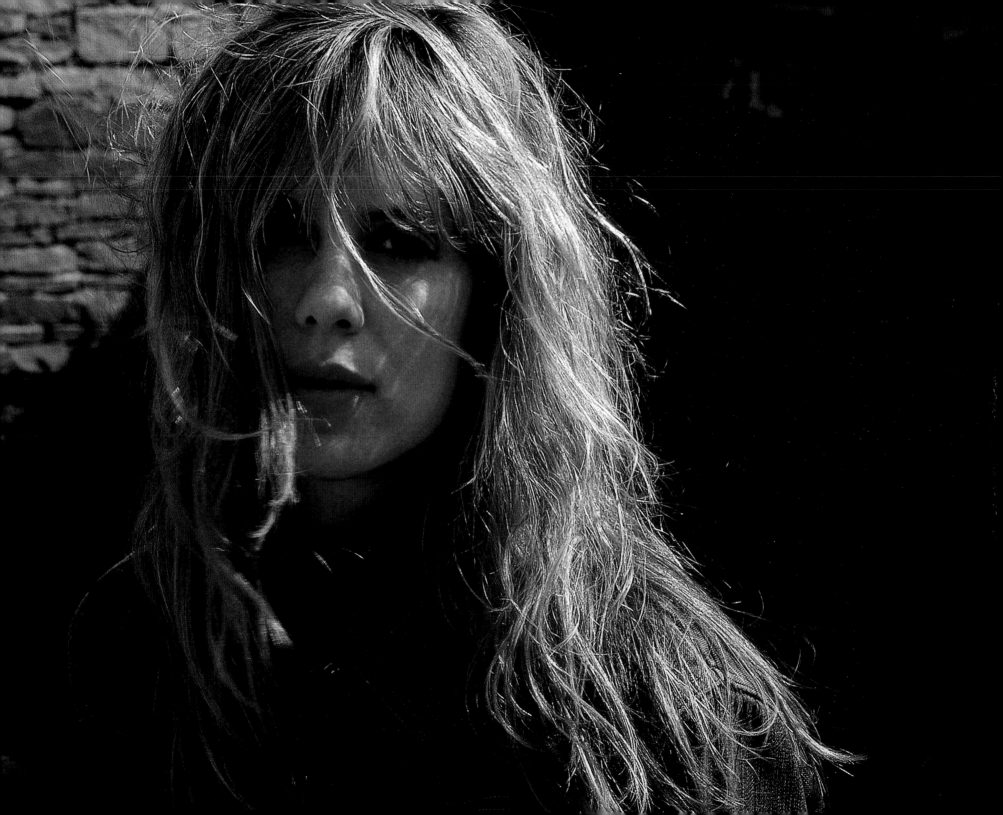

White Sands, New Mexico.

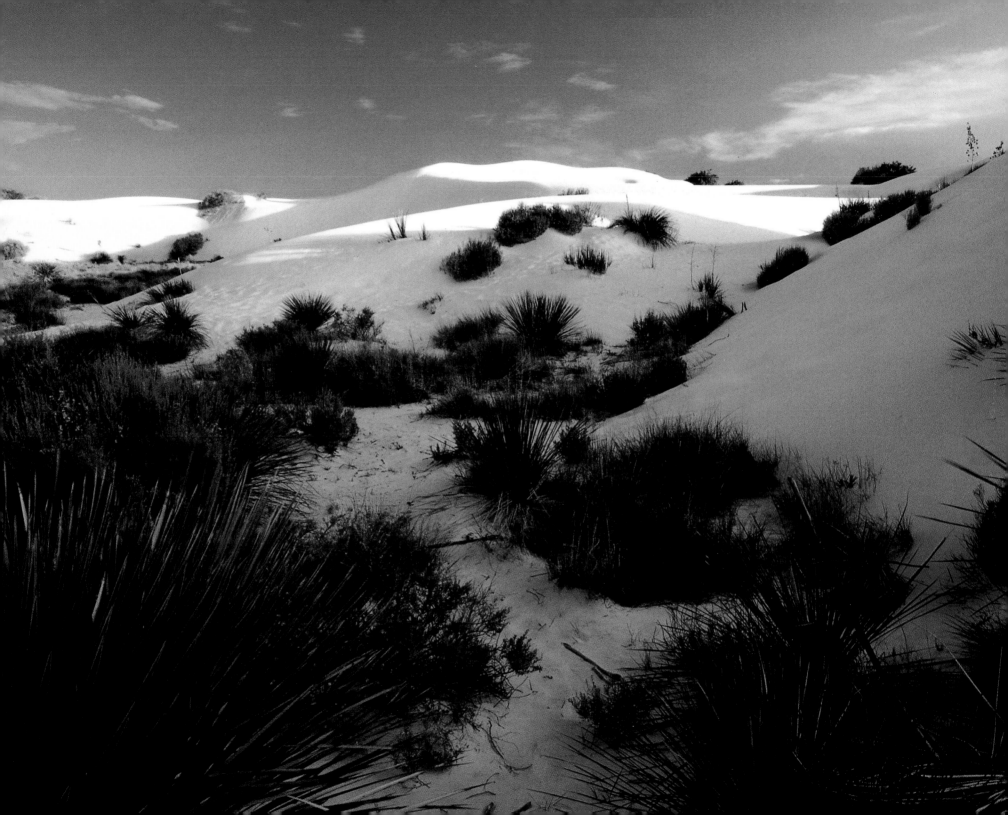

A RAINBOW OVER MONUMENT VALLEY, UTAH.

You could torture Fred and he could not tell you either the speed or the lens setting of this shot. And it appears it was taken from the balcony of his room at Gouldings Trading Post . . . near, obviously, Monument Valley. The other possibility is that he purchased this slide at the curio shop. I was staying next door and saw nothing. Fred says I was drunk.

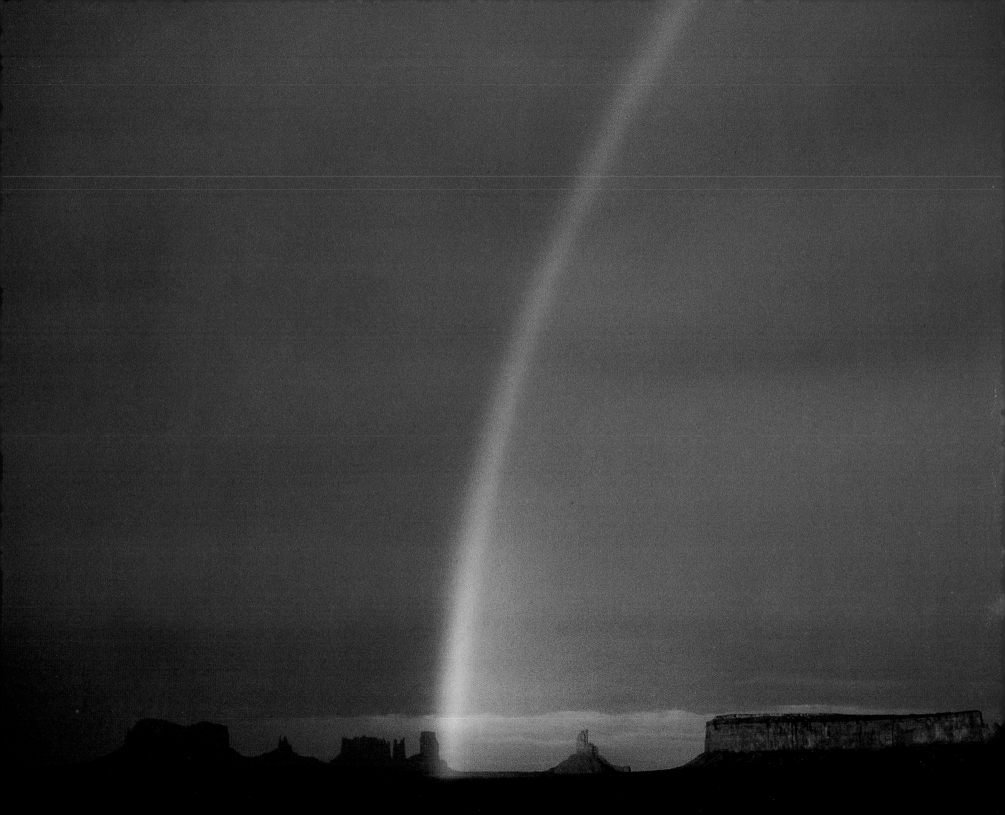

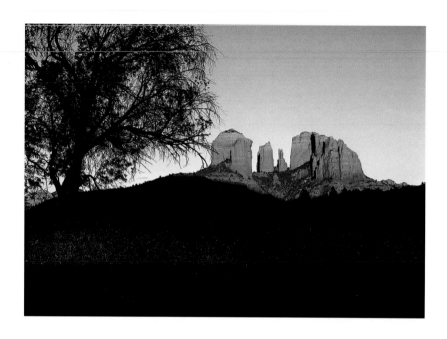

Red Rock Crossing, Oak Creek Canyon, Sedona, Arizona.

Sedona was once the most charming spot in the Southwest and the location of one of the major positive energy vortexes in the world. It is now a pretentious yuppie shithole filled with cheap curio shops and annoying fat tourists who've sucked all of the propitious energy out of the place, leaving in its void an amorphous mass of negative vibes that would piss off a priest.

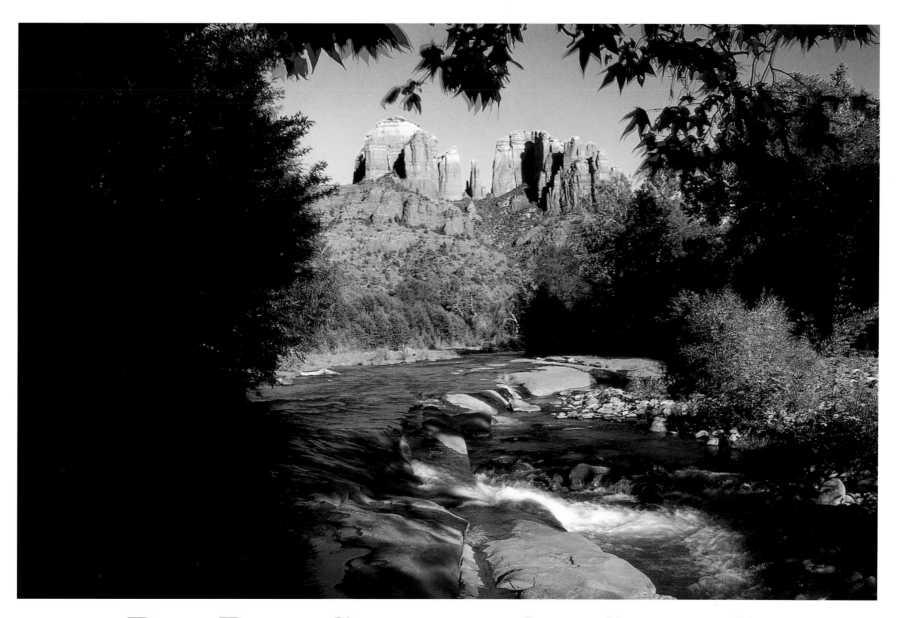

RED ROCK CROSSING, OAK CREEK CANYON,
SEDONA, ARIZONA.

The Chaco Canyon Anasazi ruins, New Mexico.

"You should be able to see the motorcade

from here, Mr. Oswald."

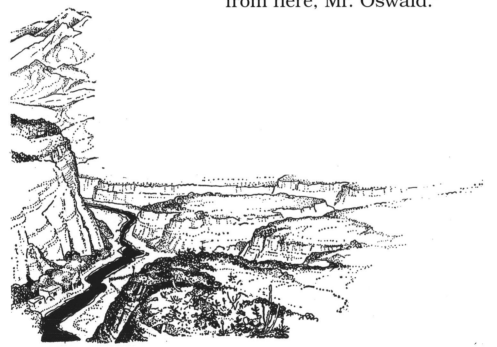

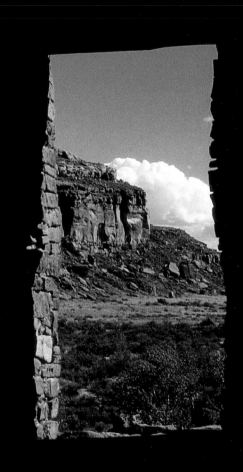

CACTUS ON FRED'S RANCH,
SANTA FE, NEW MEXICO.

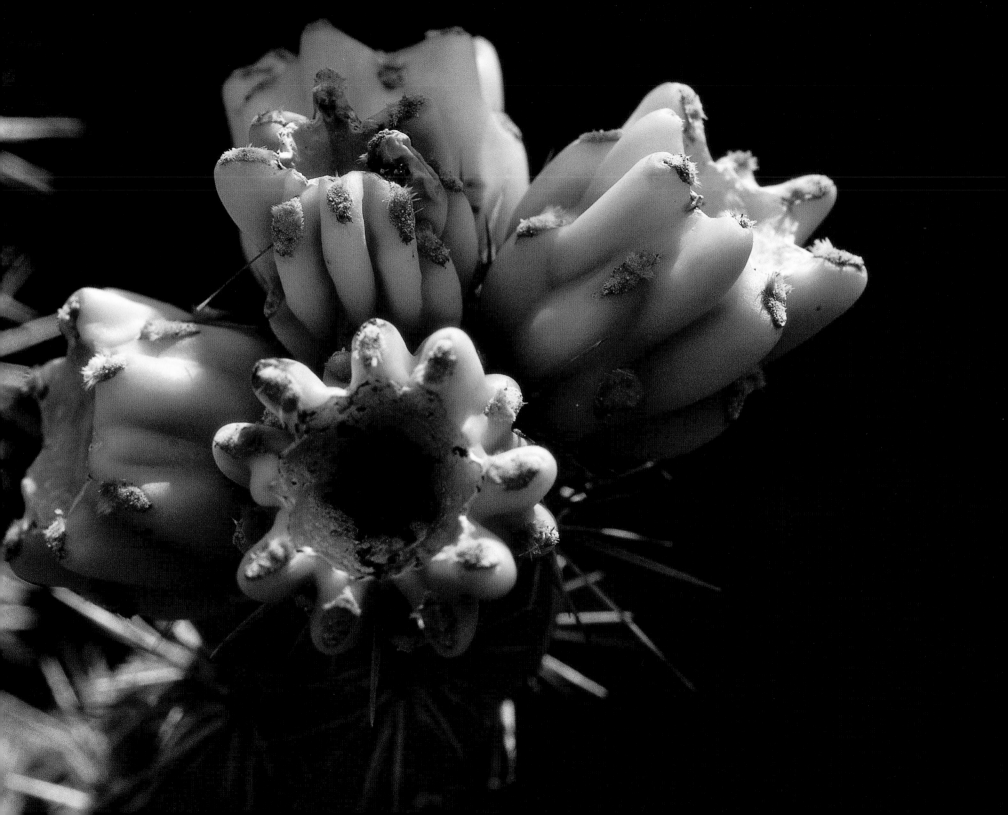

MONUMENT VALLEY, UTAH.

A rock formation they call the Right Mitten.

Or maybe it's the Left Mitten.

Probably should have checked it.

That's a tree to the left in the foreground.

I *am* sure of that.

And behind the Mitten . . .

that's the sky. And clouds.

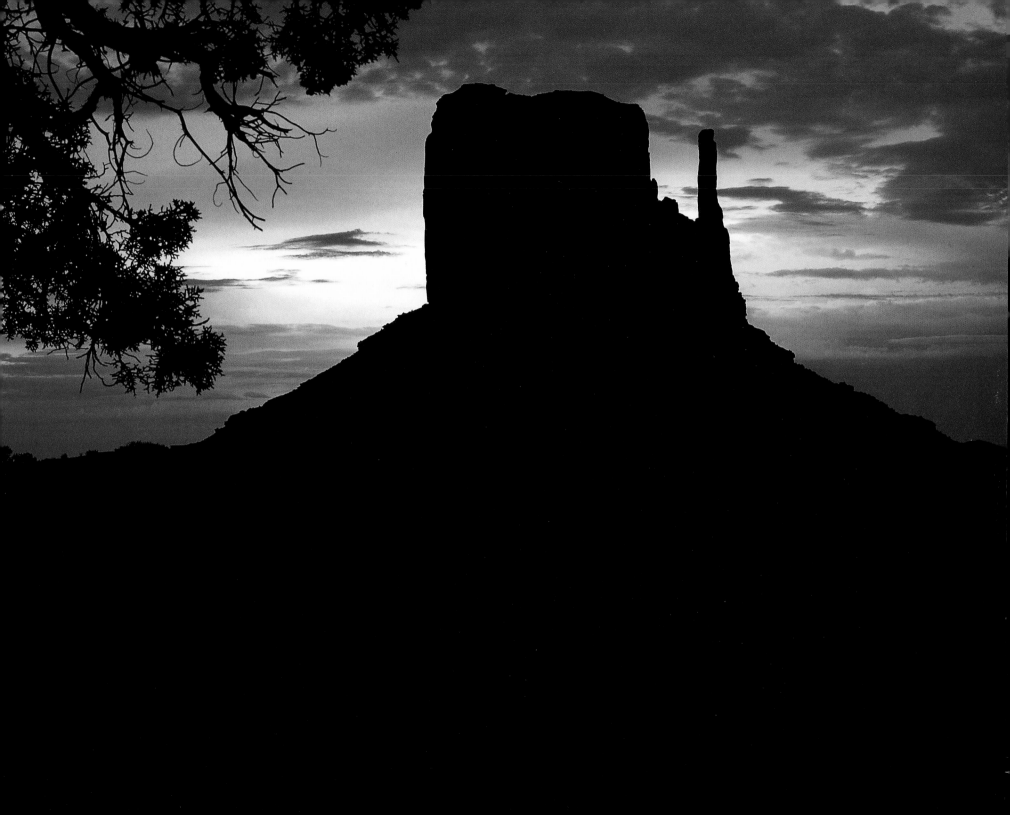

A ranch along the road from Taos, New Mexico, to Durango, Colorado.

The fresh tire tracks on what otherwise appeared to be a deserted ranch were intriguing. The snow reminded me of all the cocaine I'd done in times of less clarity. And again, I didn't have to get out of the truck.

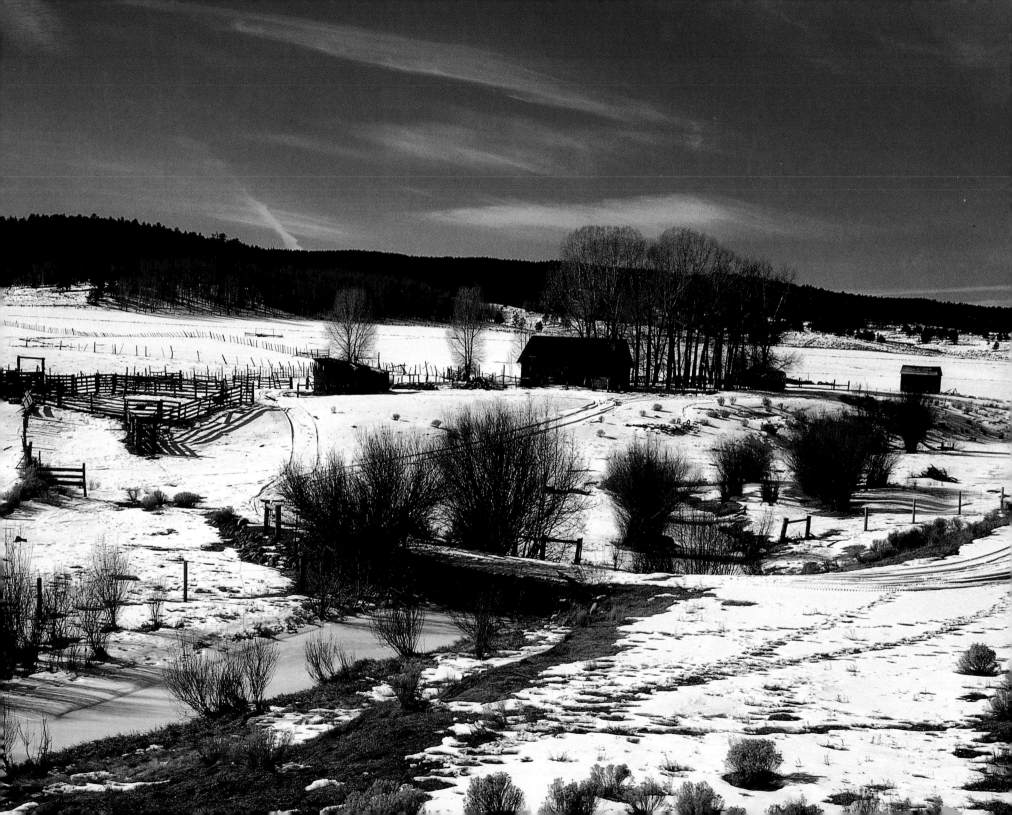

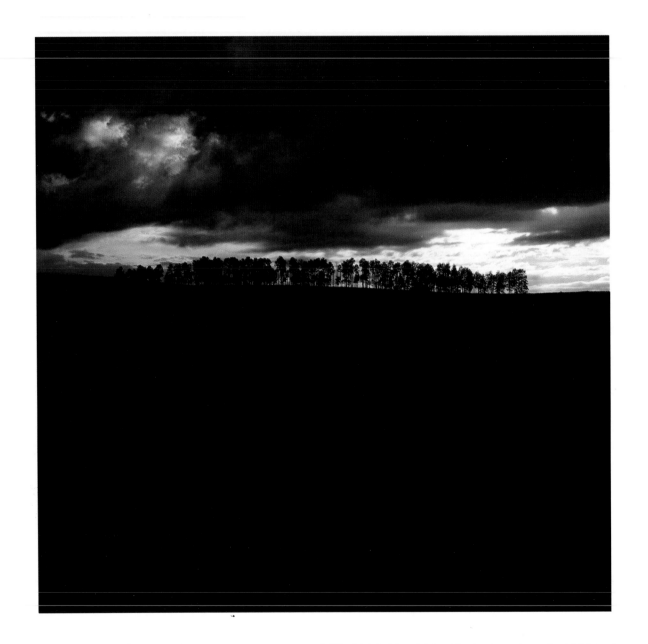

ON THE ROAD FROM TELLURIDE TO CORTEZ, COLORADO.

It's really a toss-up: Are there more assholes in Sedona, Arizona, or Telluride, Colorado? Fifty-year-old yuppie morons with ponytails running pretentious little coffee, curio, and ski shops.

And the energy sucks. God, what an awful fucking place.

And yet, five miles outta town . . . a great scene. Shot in the pouring rain. Black Angus cattle graze on an ebony field of grass in the foreground.

WHITE SANDS, NEW MEXICO.

A hundred and fifteen square miles of this shit and no ocean. A live missile firing range nearby. Nothing decent to eat for three hundred miles. Why would anyone want to go to Disney World?

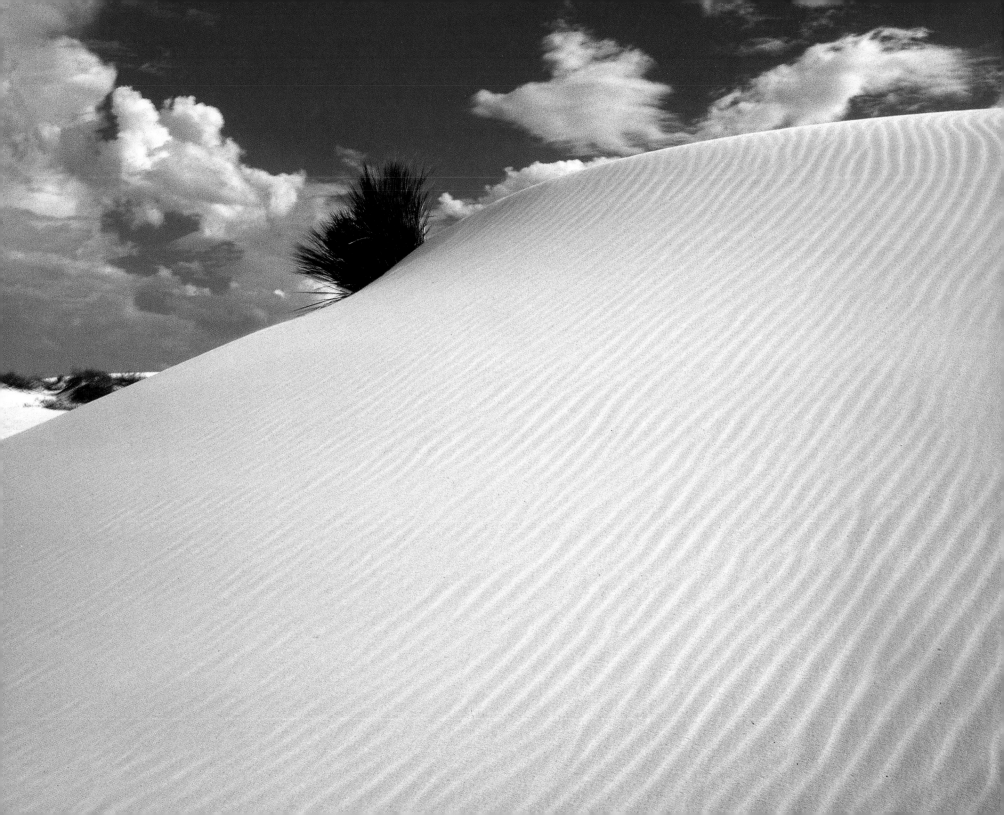

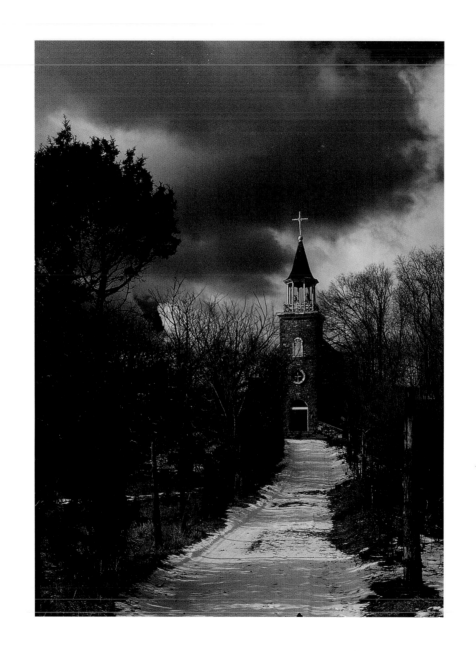

CHURCH, PECOS, NEW MEXICO.

I don't care if it rains or freezes

long as I've got my plastic Jesus

riding on the dashboard of my car

I can go a hundred miles an hour

long as I've got the all-mighty power

glued up there

by my pair

of fuzzy dice

SUPERSTITION MOUNTAIN, SOUTHERN ARIZONA.

Two shots of the west end of Superstition Mountain. Taken, according to Fred, on the same afternoon with dramatically different light conditions. Very suspicious, if you ask me. I don't care what the light does, the fucking mountain doesn't change colors. If there are any special prosecutors left over from investigating the Clintons, perhaps they can look into this obvious deception.

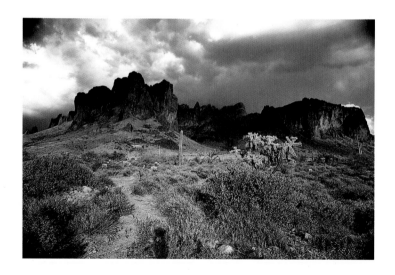

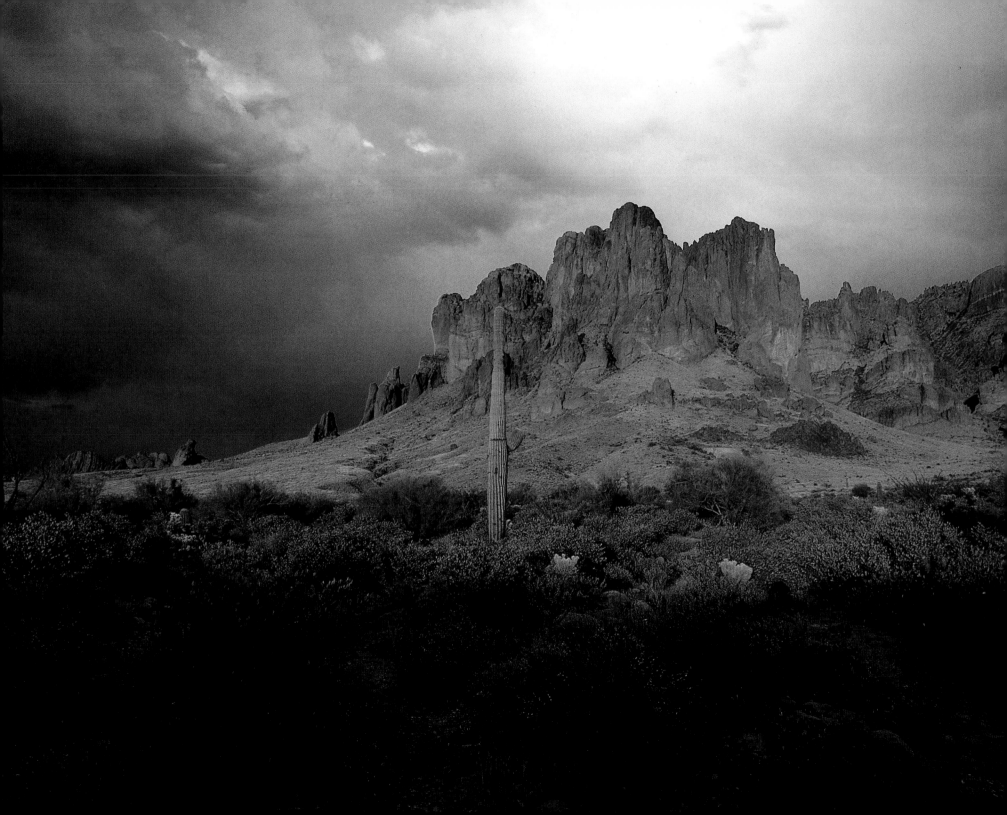

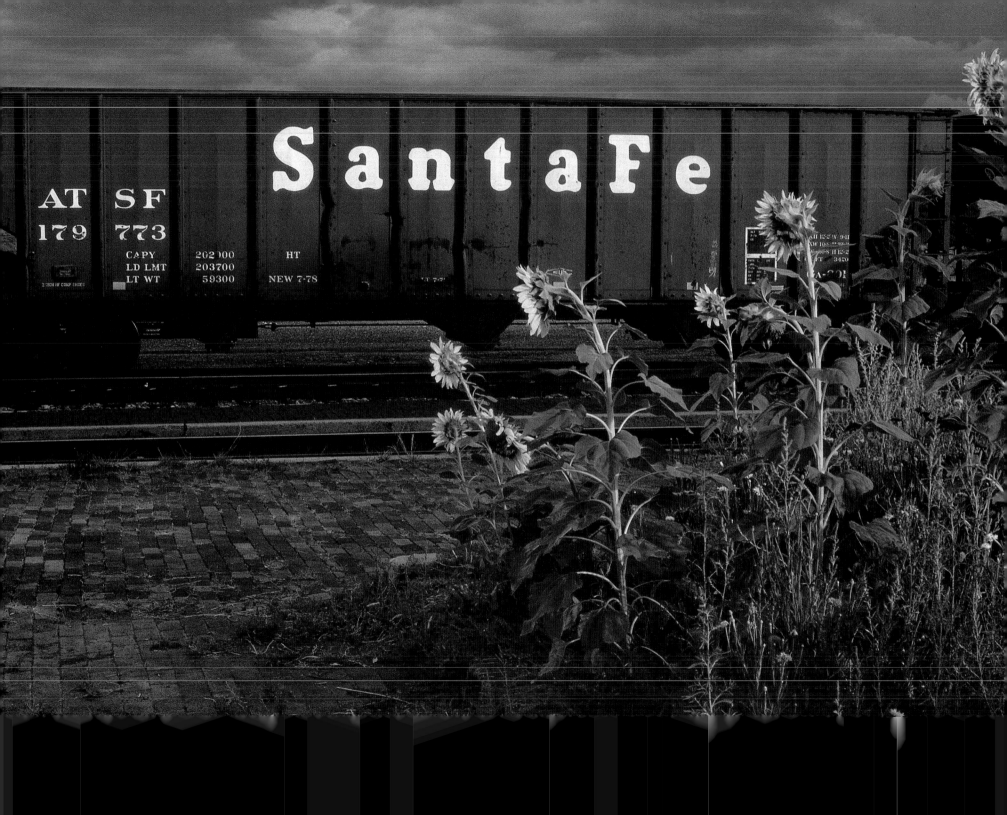

Railyard, Lamy, New Mexico.

Ideally, the sunflowers should be facing the camera. Obviously they're not. Had I taken this photograph with the flowers facing the camera, it would have been a shot of my wife, Deirdre Coleman, standing behind them, pointing out that they were facing the wrong way.

She did that anyway.

I told her to go wait in the truck.

She punched me.

MONUMENT VALLEY, UTAH.

The Southwestern equivalent of the New York City skyline minus anything with Donald Trump's name on it. A flashing, neon temperature sign might, however, be helpful.

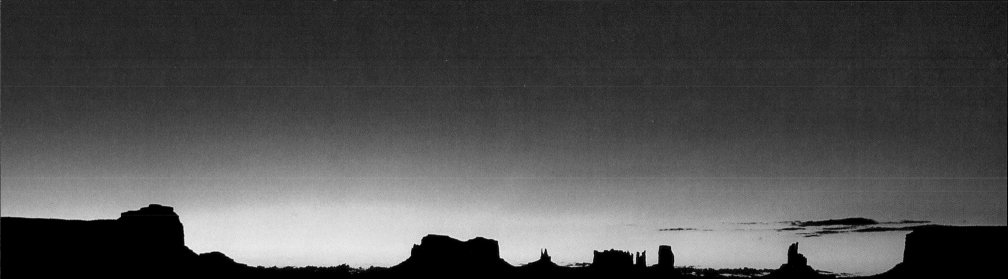

Monument Valley, Utah, from the air.

After talking a local pilot into taking the doors off his single-engine Cessna, tying ourselves to our seats, and hanging out of the plane, we flew over the valley shortly after a storm, attempting to re-create the famous shot taken by Ernst Haas. We didn't.

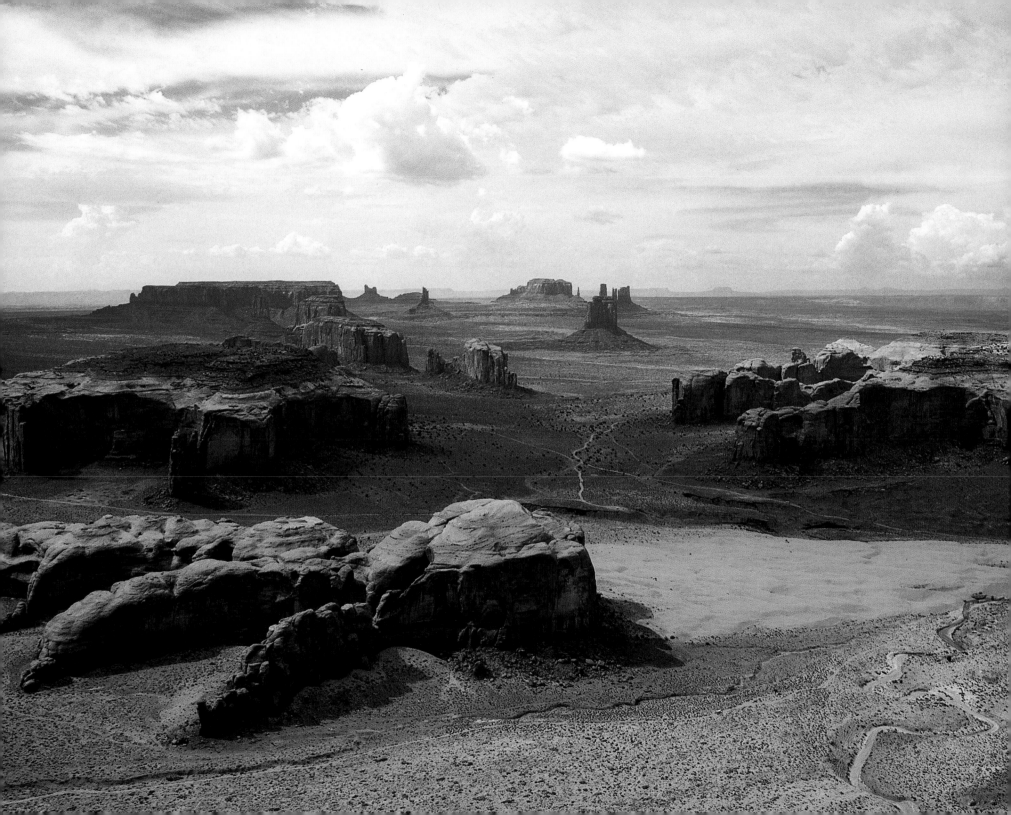

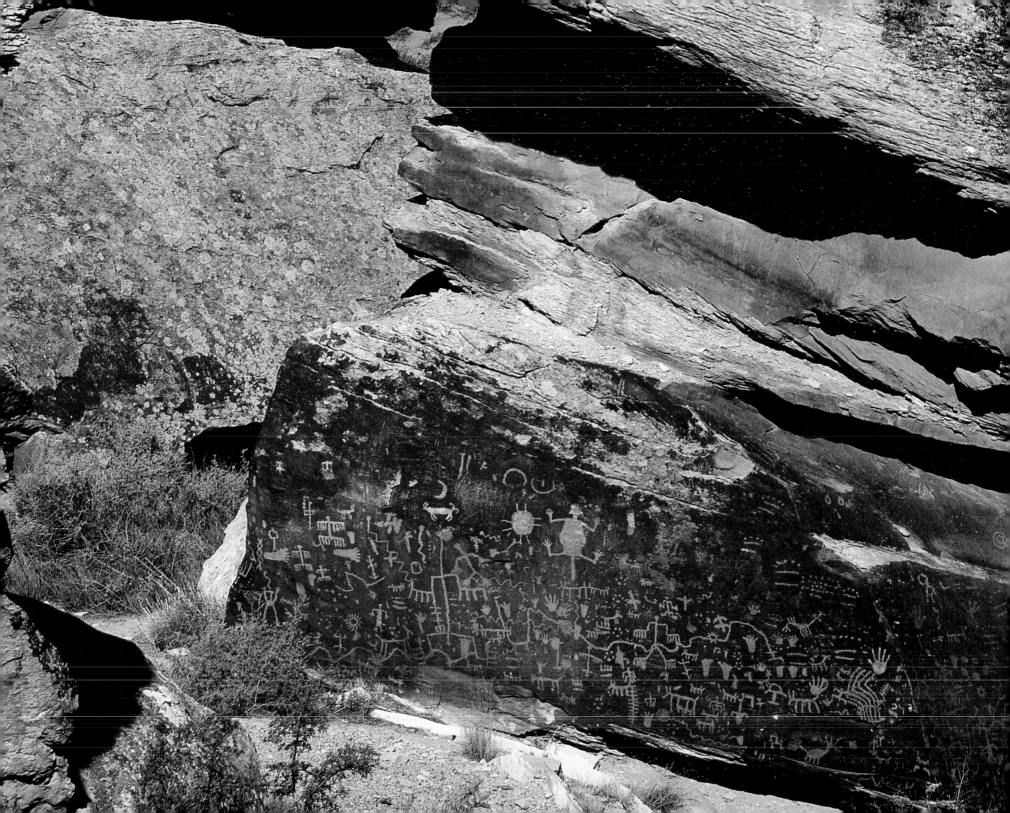

NEWSPAPER ROCK, THE PAINTED DESERT, ARIZONA.

These petroglyphs are believed to be the work of the Anasazi, a Native American people inhabiting southern Colorado and Utah and northern New Mexico and Arizona from about A.D. 100 and whose descendants are the present-day Pueblo peoples.

We arrest assholes in New York City for drawing this kind of shit on subway cars.

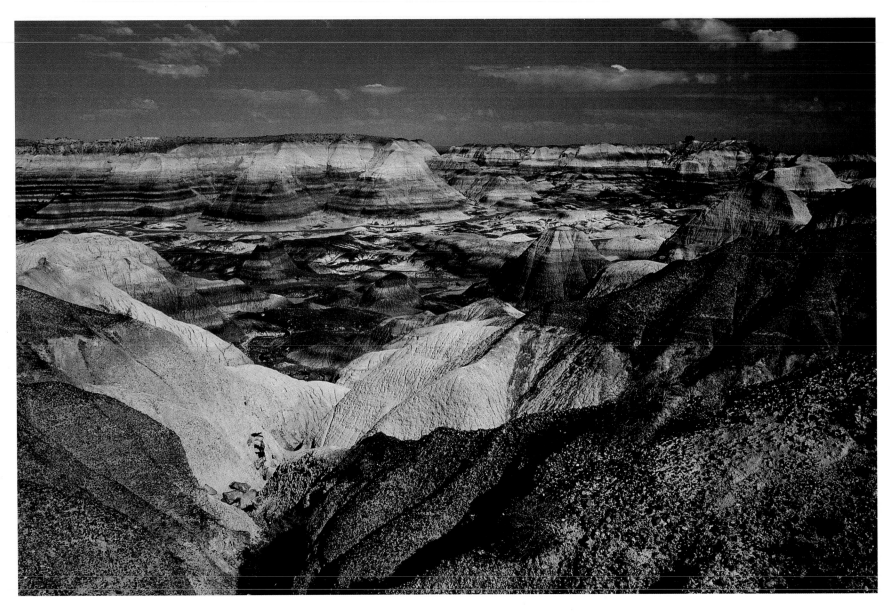

BLUE MESA, THE PAINTED DESERT, ARIZONA.

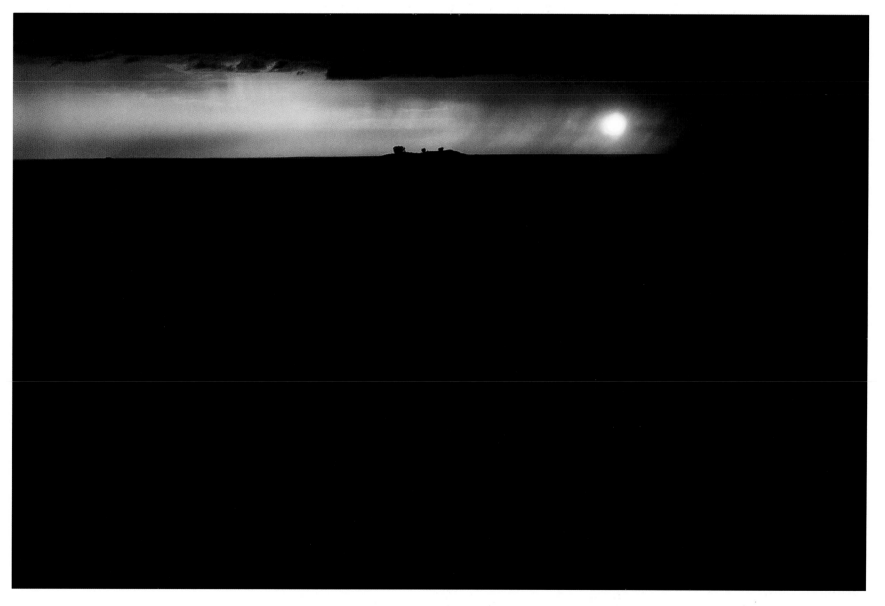

SUNSET AT BLUE MESA, ARIZONA.

Monument Valley, Utah.

Fred paid this Navajo woman forty bucks to herd her sheep out in an area where we could photograph them. They were in this formation for about two minutes . . . then the noise of the cameras spooked them and we turned a lovely tranquil Southwestern scene into a full-blown Iraqi fire drill. Screaming sheep all over half of Utah. Jesus, what a mess.

Fred's comment at the time seemed particularly incisive. "We just want to take their picture, not have sex with them. Although," he added, "a couple of 'em are kinda cute."

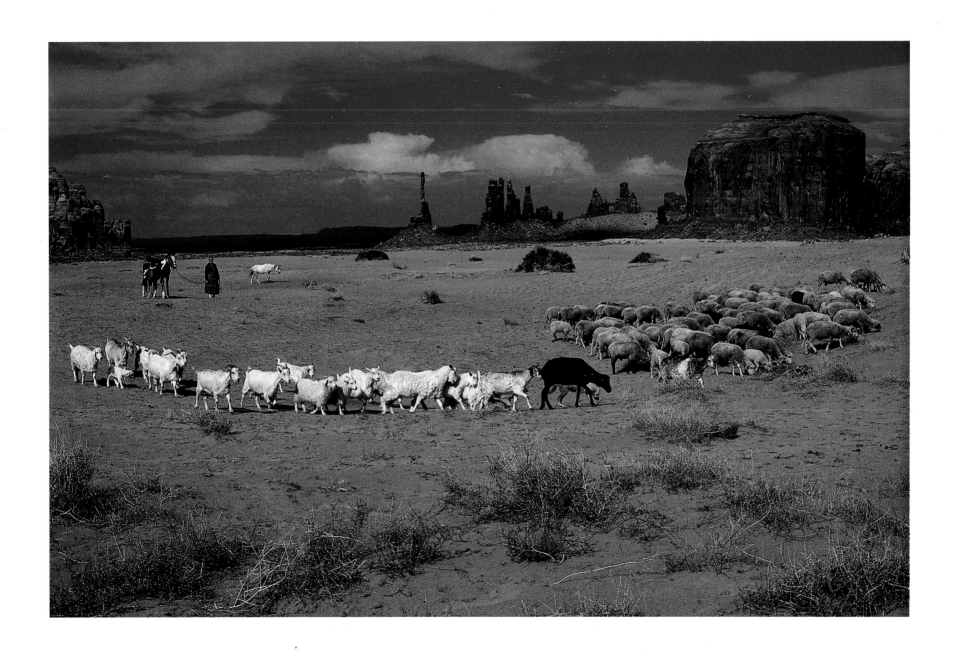

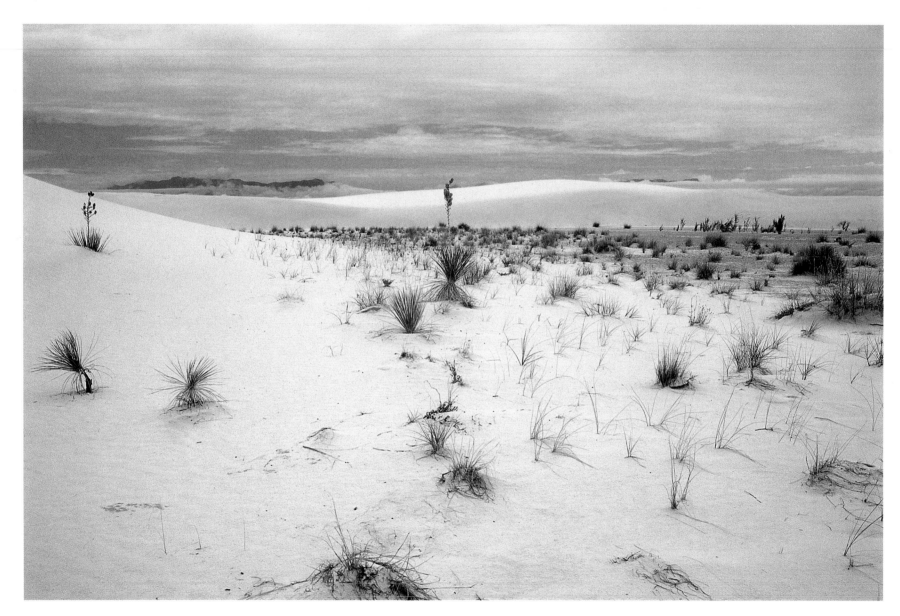

WHITE SANDS, NEW MEXICO.

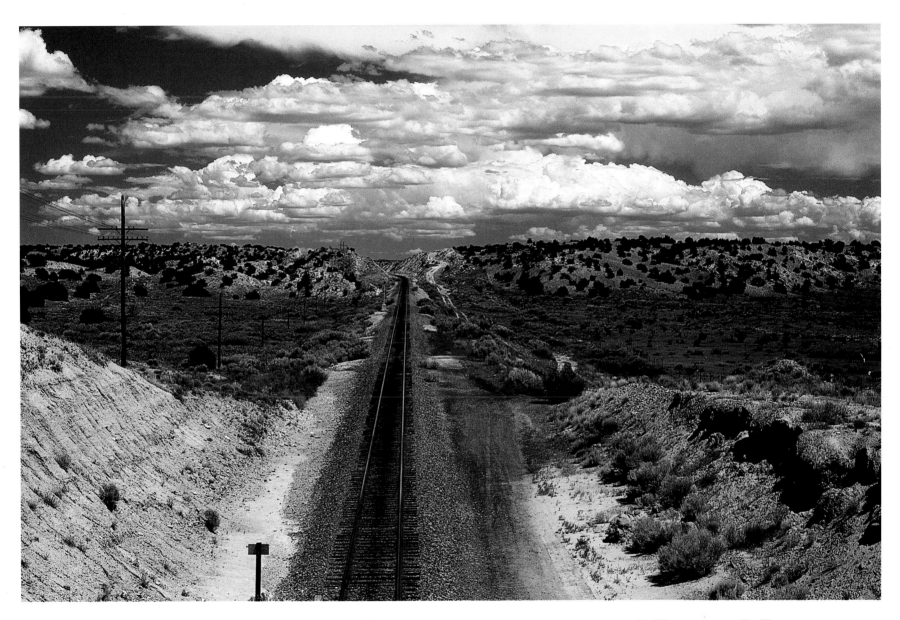

SOMEWHERE IN NEW MEXICO.

FRED (FRED NOONAN) IMUS, MONUMENT VALLEY, UTAH.

Fred waits while the pilot

removes the door from the plane.

How stupid is this? Hey, long as we're at it,

why not take the wings off, too?

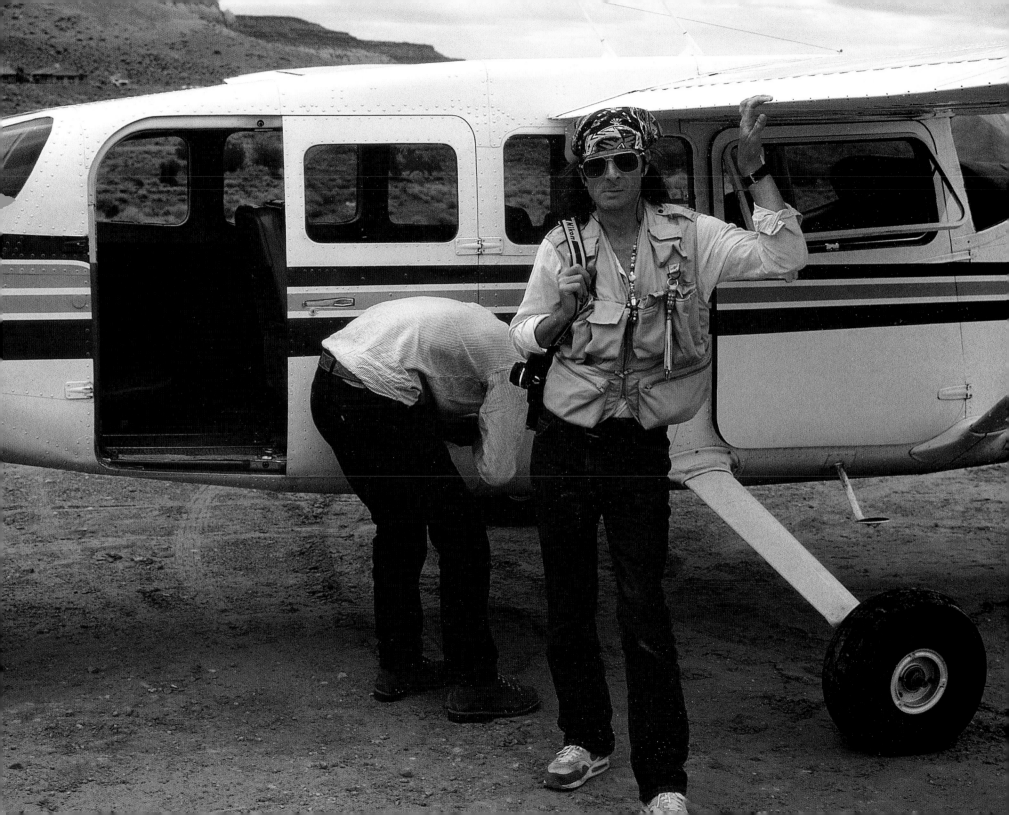

SPIDER ROCK, CANYON DE CHELLY, ARIZONA.

If Bill Clinton showed *this* to Paula Corbin Jones, would he ask her to "kiss it"?

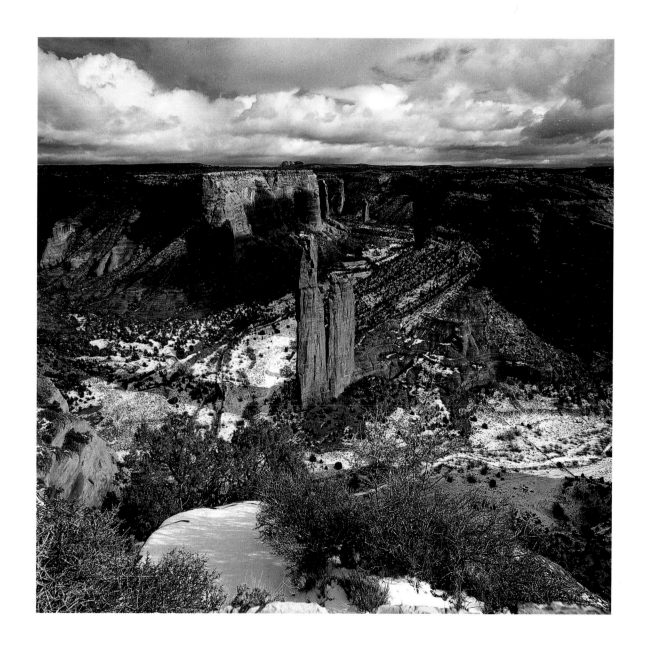

White House Ruin, Canyon de Chelly, near Chinle, Arizona.

"I'm telling you, Bill, we hang on to this, some asshole will buy it and we can still send Chelsea to college."

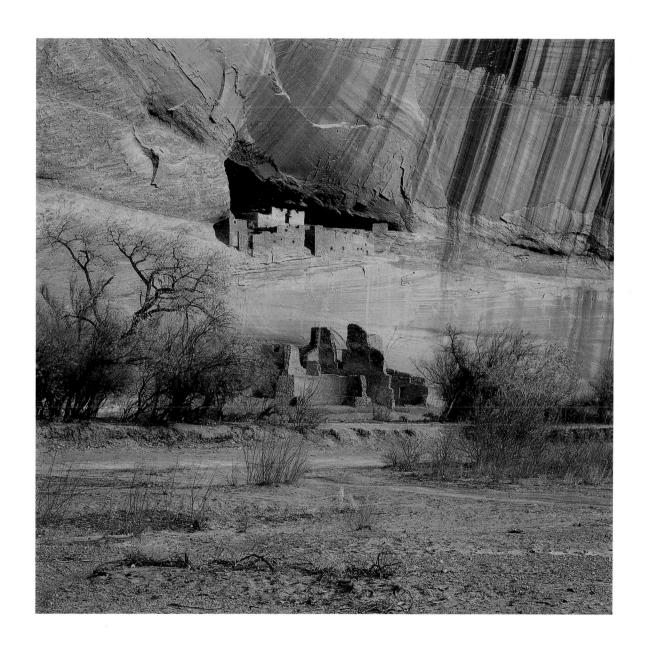

LAKE POWELL, NEAR THE BUFFALO BASIN MARINA IN UTAH.

It is almost impossible to take a photograph of Lake Powell that does not include a family of fat drunks on a houseboat. Or equally drunk redneck morons in speedboats.

This shot includes neither and is unique on that basis alone.

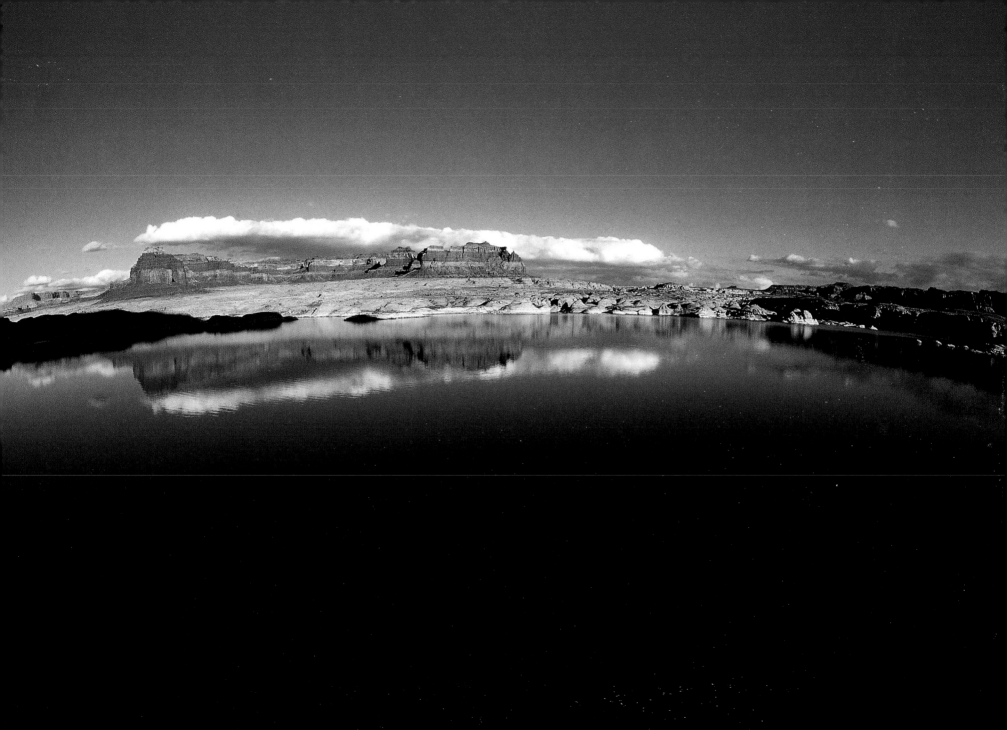

MONUMENT VALLEY, UTAH.

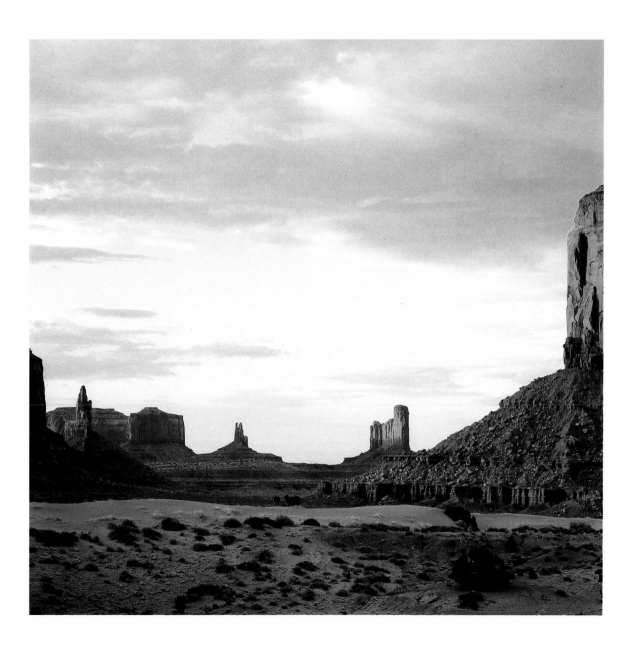

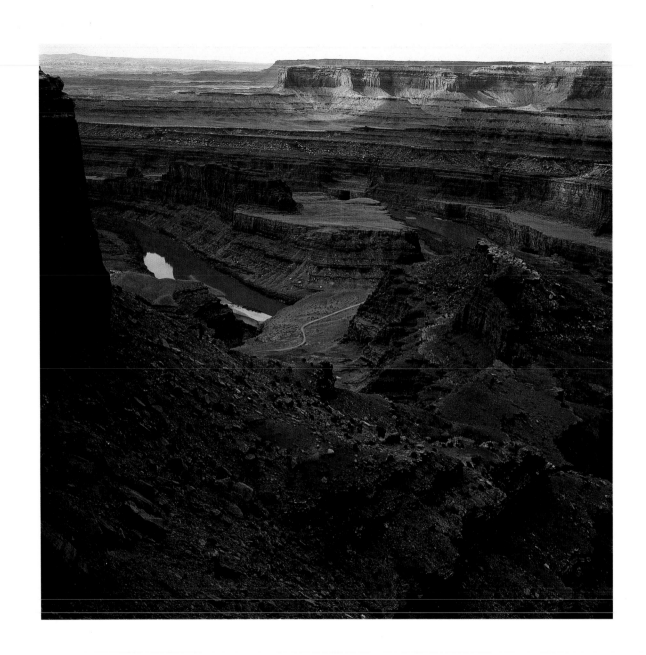

Dead Horse Point, Horseshoe Canyon, near Moab, Utah.

The mesa in the middle of this photograph is the one Susan Sarandon and Geena Davis drove off of in *Thelma & Louise*. They *said* it was the Grand Canyon. They lied. Therefore, I'm glad they died.

Notice the tourists standing on the cliff in the upper left of the photograph. Bus-loads of these bastards have nearly ruined the country. How great would it have been had one of them slipped off during this shot?

FARMINGTON,
NEW MEXICO.

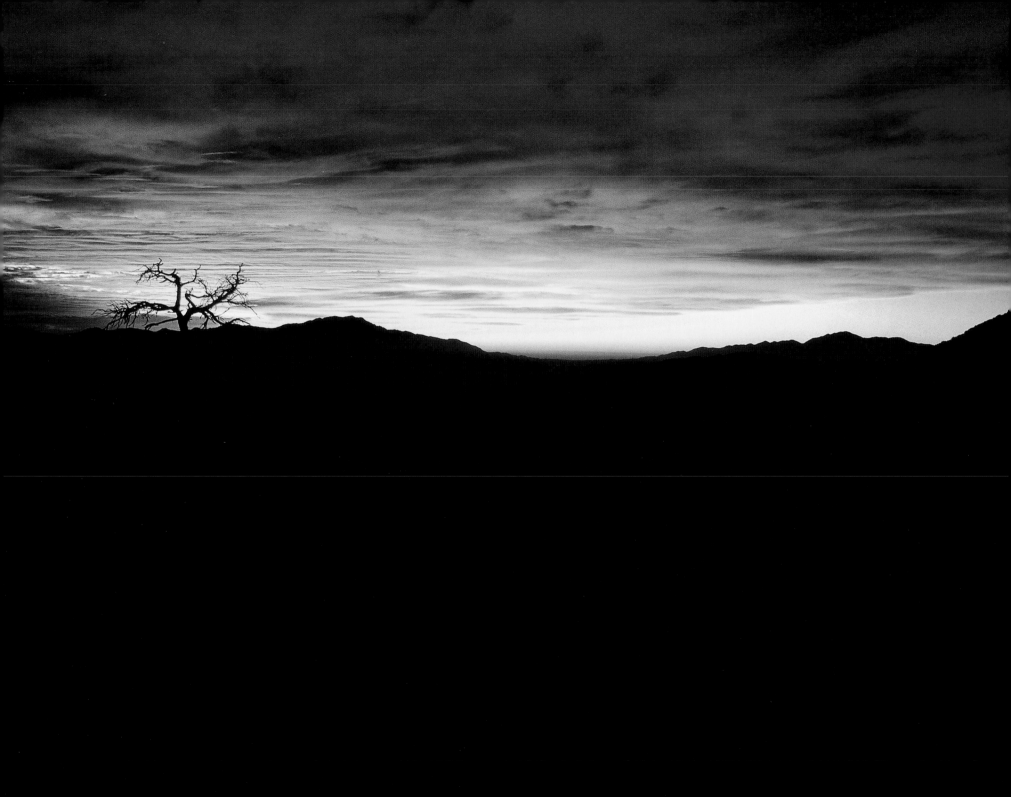

DURANGO, COLORADO RODEO.

Nice plug for Wendy's. Think the horse will wind up in one of their bacon cheese-burgers? By the way, that is not Dave Thomas on the horse.

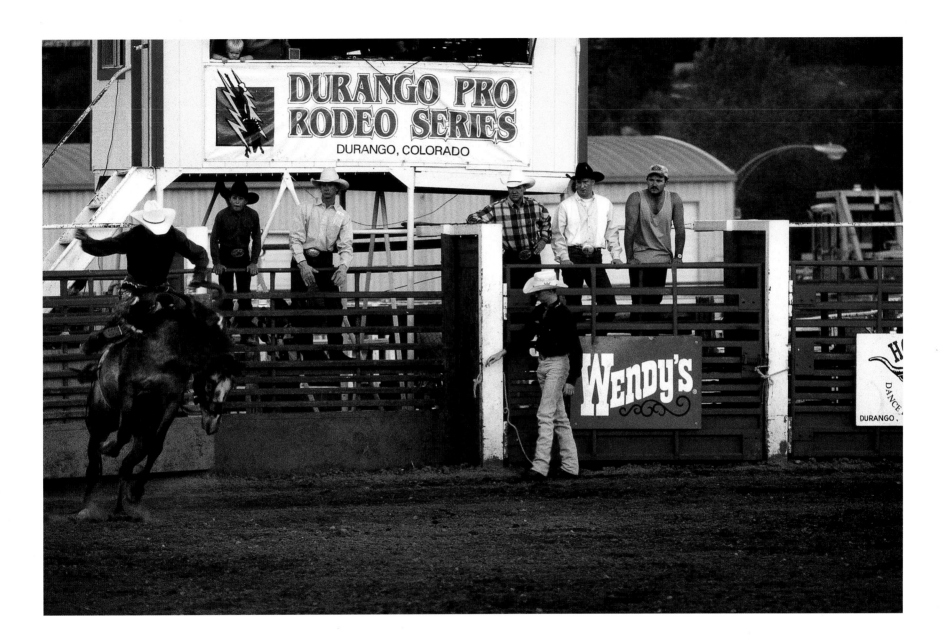

CANYON DE CHELLY, ARIZONA.

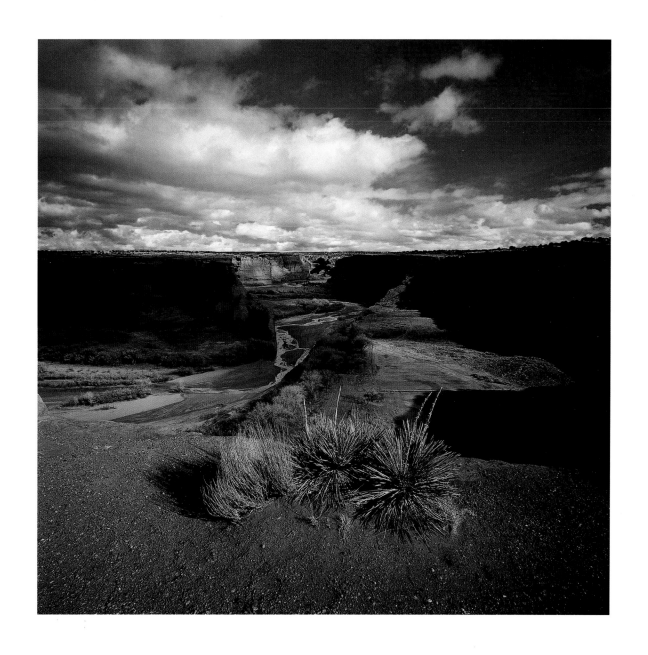

Acknowledgments

Fred and I would like to thank our agent at ICM, Lobster Newberg, for negotiating the chump advance for this certain bestseller—an embarrassingly measly amount of money that we suspect is a result of her precipitous loss of power and prestige.

Rochelle Udell (the editor in chief of *Self* magazine) *did* do a wonderful job. Of all those associated with this book, she stands alone as the one competent soul on the project . . . with the exception of Jennifer Webb at Villard Books, who was genuinely enthusiastic and offered a number of terrific suggestions.

Thanks as well to Bruce Mitchell at Fuji Film. To Richard LaPinto at Nikon and Jim Morton at Hasselblad. To Lorenzo Gasperini/Gitzo Tripods, and all the people at Alkit Pro Camera in New York City.

Thanks to Joe Hoffmann/Tanacolor Graphics for his technical and esthetic advice and counsel and also to David Jurist at Tanagraphics. To Ken Lieberman/Ken

Lieberman Laboratories. Thanks as well to the Navajo Nation, the Navajo Nation Police, the National Park Service, Senator John McCain, and the individual guides who took us places we otherwise would have never known about—especially Gail Gaylor of Page, Arizona.

And a special thanks to my wife, Deirdre Coleman, who researched several of our trips, discovered the slot canyons—persuading me to hike to them while carrying my cameras for me—and provided enormously helpful creative ideas for many of the shots in this book (she claims *all* of them). She was a great sport even when her blood sugar sank to dangerous levels.

ABOUT THE AUTHORS

FRED IMUS lives in Santa Fe, New Mexico, and has been neither nominated for, nor won, the Pulitzer Prize. He owns and operates the Auto Body Express. He is currently working on his memoirs with the author Mike Lupica.

DON IMUS is Fred's older brother. He is the host of the nationally syndicated *Imus in the Morning* radio and television programs.

They are not members of Mensa.

PHOTO CREDITS
AND INFORMATION

Page 3 Don Imus, 1996, Nikon F3, 50mm, Fuji

Page 4 Don Imus, 1988, Nikon F2, 24mm, Kodachrome

Page 7 Don Imus, 1988, Nikon F3, 24mm, Kodachrome

Page 8 Fred Imus, 1988, Nikon F2, 50mm, Kodachrome

Page 9 Fred Imus, 1992, Nikon F3, 50mm, Kodachrome

Page 10 Don Imus, 1996, Nikon F3, 105mm, Fuji

Page 13 Fred Imus, 1988, Nikon F3, 50mm, Kodachrome

Page 15 Fred Imus, 1988, Nikon F3, 24mm, Kodachrome

Page 16 Don Imus, 1995, Hasselblad 500 ELM, 60mm, Fuji

Page 19 Fred Imus, 1988, Nikon F2, 24mm, Kodachrome

Page 21 Don Imus, 1989, Nikon F3, 24mm, Kodachrome

Page 23 Don Imus, 1996, Nikon F3, 300mm EO, Fuji

Page 25 Don Imus, 1976, Nikon F2, 50mm, Kodachrome

Page 26 Don Imus, 1982, Nikon F3, 55mm, Kodachrome

Page 29 Don Imus, 1994, Nikon F3, 35mm, Kodachrome

Page 31 Don Imus, 1996, Hasselblad 500 ELM, 60mm, Fuji

Page 33 Don Imus, 1996, Hasselblad 500 ELM, 60mm, Fuji

Page 35 Don Imus, 1996, Hasselblad 500 ELM, 60mm, Fuji

Page 37 Don Imus, 1996, Hasselblad 500 ELM, 80mm, Fuji

Page 39 Don Imus, 1996, Hasselblad 500 ELM, 35mm, Fuji

Page 41 Don Imus, 1996, Nikon F3, 35mm, Kodachrome

Page 43 Don Imus, 1996, Nikon F3, 35mm, Kodachrome

Page 45 Don Imus, 1996, Nikon F3, 35mm, Kodachrome

Page 47 Don Imus, 1996, Nikon F3, 55mm, Fuji

Page 49 Fred Imus, 1987, Nikon F2, 50mm, Kodachrome

Page 51 Don Imus, 1976, Nikon F2, 50mm, Kodachrome

Page 52 Don Imus, 1996, Nikon F3, 35mm, Fuji

Page 53 Don Imus, 1996, Nikon F3, 35mm, Fuji

Page 55 Don Imus, 1994, Nikon F3, 205mm, Kodachrome

Page 57 Don Imus, 1996, Nikon F3, 24mm, Fuji

Page 59 Fred Imus, 1988, Nikon F3, 105mm, Kodachrome

Page 60 Fred Imus, 1988, Nikon F3, 50mm, Kodachrome

Page 61 Don Imus, 1988, Nikon F3, 50mm, Kodachrome

 (a triple exposure using red, green, and blue filters)